The Drawings and Paintings
of Coral Gables and Rome

THOMAS A. SPAIN

Steven Fett & Edgar Sarli

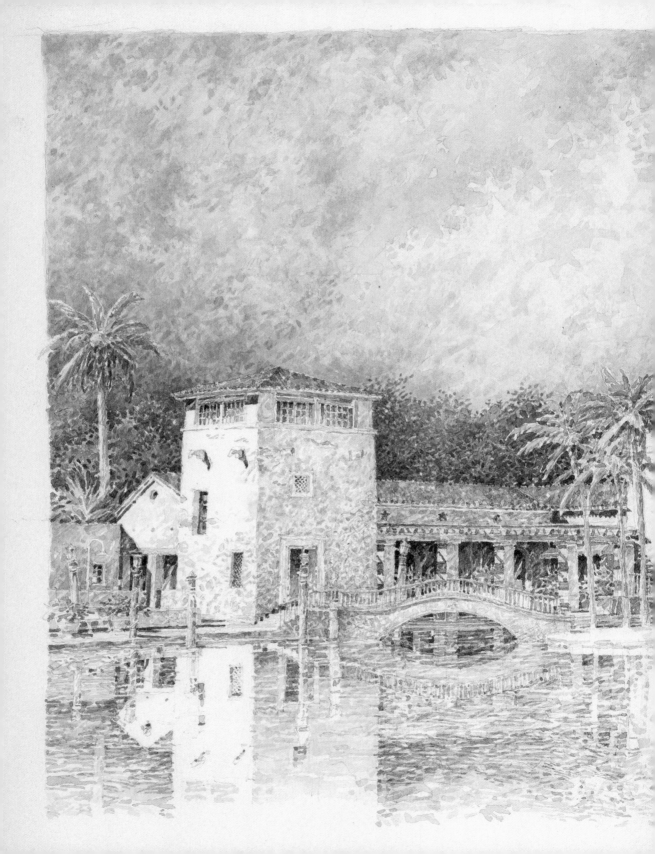

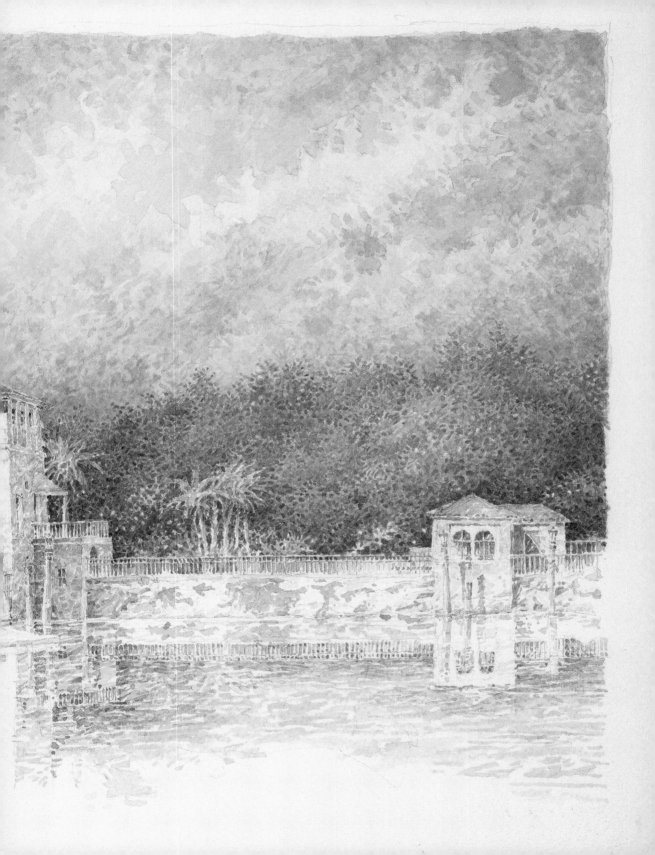

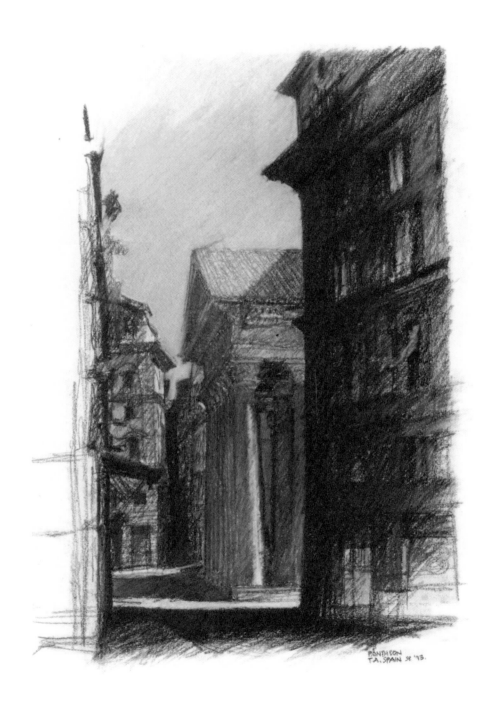

PANTHEON
T.A. SPAIN se '93.

The Drawings and Paintings
of Coral Gables and Rome

THOMAS A. SPAIN

Edited by
Steven Fett & Edgar Sarli

Transcribed Lecture by
Jorge Hernandez

University of Miami School of Architecture

OSCAR RIERA OJEDA
PUBLISHERS

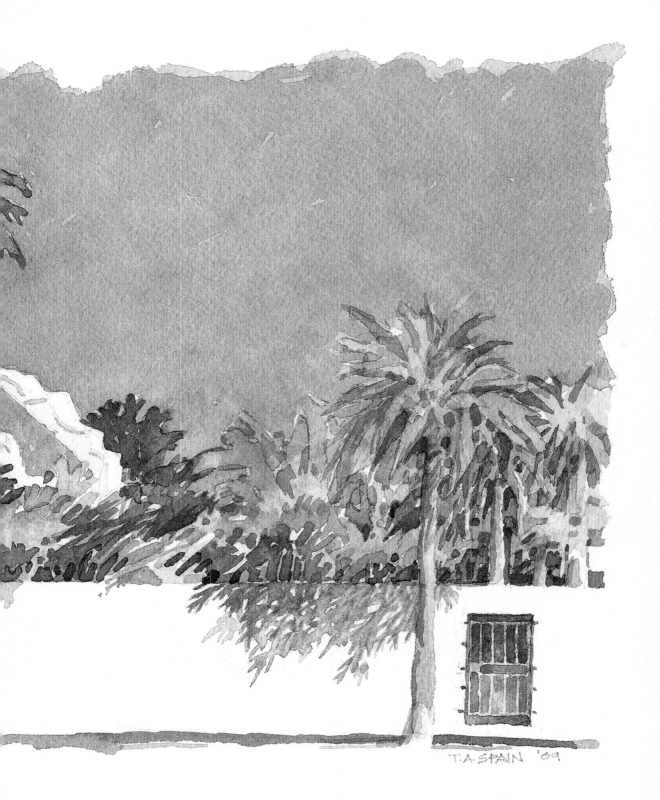

T.A. SPAIN '09

Dedication

We would like to thank Thomas A. Spain for opening up his home and his world of art to us. We are forever grateful for the hours of delightful conversation and for the insight and knowledge he humbly bestowed on us. Additionally, we would like to thank the following people for their help and collaboration in putting this modest, yet meaningful publication together.

Wendy Caraballo

Adib Cure

Dean Rodolphe el Khoury

Jorge Hernandez

Tamar Loeb

Carie Penabad

Dona Spain

Tina Zeng

and

A special thank you to John H. Fett who generously edited our words, thereby transforming a collection of essays, interviews and lectures into a book.

SF & ES

Table of Contents

Acknowledgments

Thomas A. Spain, the editors and the University of Miami,
School of Architecture, wish to thank the following
institutions and individuals for their generous support.

The City of Coral Gables

Luis and Lexi C.A. Segre Revuelta

Robert and Annie Behar

John and Jennifer Forbes

Rolando and Lucy Llanes

Albert Menendez and Maria Santovenia

Glenn Pratt and Letitia Cason

Introduction

By Steven Fett

Blank House Study, 1988
Colored pencil

Thomas A. Spain, architect, recently retired from the University of Miami School of Architecture where he'd been a faculty member since 1966. His enormous talent and unwavering devotion to teaching design and drawing have left an indelible impact on the students he taught over the past two generations. Especially known on campus for his drawings of Rome, through his almost yearly visits from 1991 to 2014 with his students, Spain's extensive and brilliant collection of work focuses on memorable locations, revisited and redrawn over the years. The work demonstrates how time and acute observation lead to new ways of seeing, while revealing the circumstantial relationship between author, subject and medium.

Outside of the classroom, Spain's fine art series is the architect's most labored and personal work. It focuses on Coral Gables, the "City Beautiful" suburb of Miami, and Spain's home. Developed by George Merrick in the 1920s, Coral Gables is a visual paradise, thoughtfully weaving lush landscapes of banyan trees and palms with its pioneer architectural monuments, faithfully

executed in the Mediterranean Revival style. Spain, diverse in his choice of medium, alternates between pencil, watercolor, and pastel, using the unique characteristics of each to establish mood and artistic intent. The common thread of the work in the series is the contrast between the natural landscapes and the man-made landmarks that define Coral Gables. In the pencil drawings, place powerfully informs the work as the intense sunlight of South Florida is beautifully rendered through soft edges and deep shadows. In the watercolor series, unexpected attention is given to utilitarian parts of buildings contrasting with the more recognizable front façades, resulting in provocative, idealized compositions.

An exhibition of Thomas A. Spain's work, held in the Korach Gallery at the University of Miami School of Architecture, from Aug. 25 to Sept. 12, 2014, was the catalyst for this publication. Although not strictly a catalog of that show, this book does follow the curatorial direction of the exhibit insomuch as it categorizes Spain's work into two distinct categories: Rome and Coral Gables. Accompanying the work are essays by Steven Fett and Edgar Sarli, an interview with Spain, and a transcribed edited lecture about Spain by Jorge Hernandez, presented on the evening of the exhibition's opening. Fett, Sarli and Hernandez are all practicing architects and were colleagues of Spain at the University of Miami, School of Architecture.

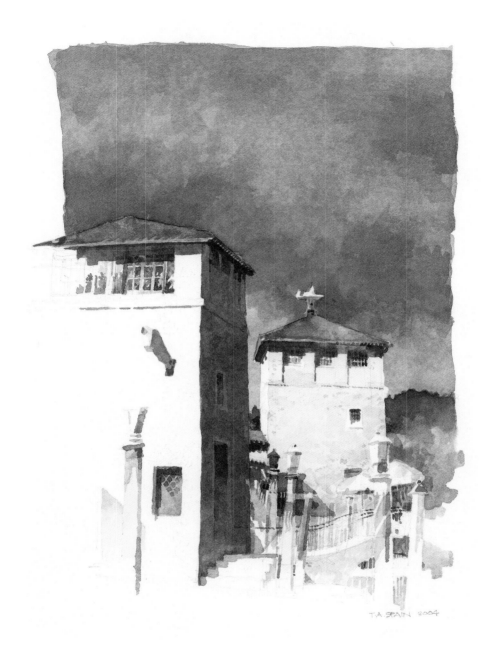

Venetian Pool, 2004
Watercolor

Steven Fett

17

City Hall, 2000
Watercolor

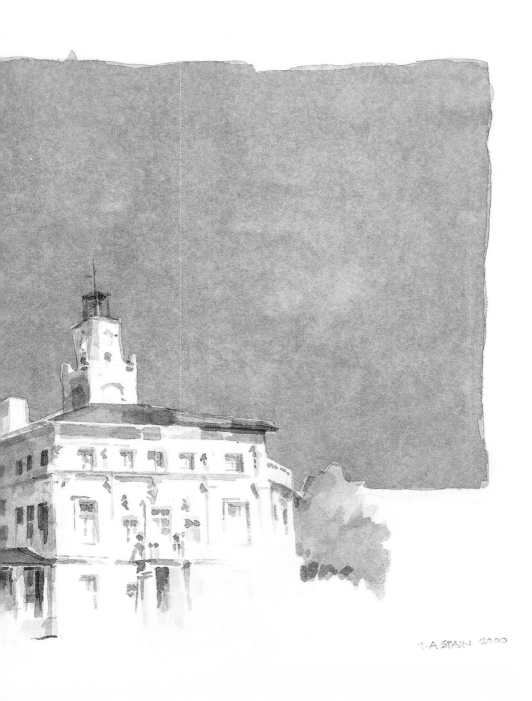

Steven Fett

DeSoto Plaza, 2000
Watercolor

DeSoto Fountain, 1999
Watercolor

Introduction

Merrick House, 2007-11
Watercolor

Steven Fett

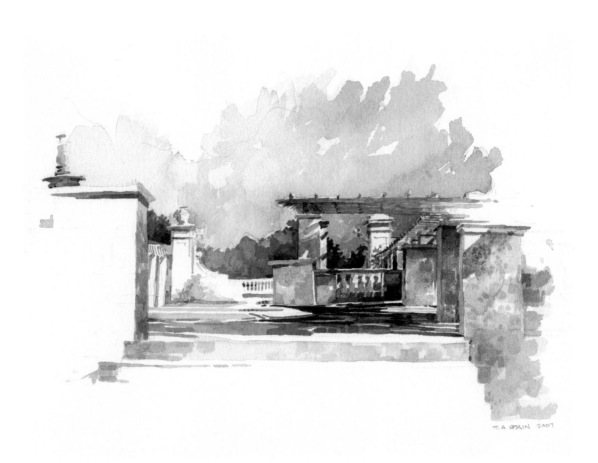

Prado Entrance, 2007
Watercolor

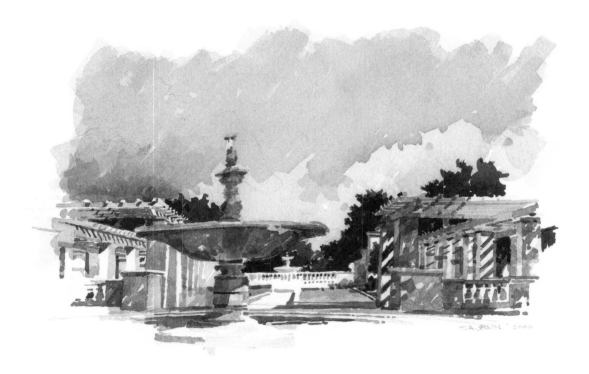

Prado Entrance, 2006
Watercolor

Steven Fett

The Drawings of Rome

By Steven Fett

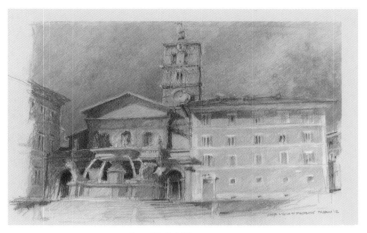

Santa Maria in Trastevere, 2012
Color Pastel

Thomas Spain doesn't refer to himself as an artist. He believes that to be called an artist one needs to make a living selling art. Spain, a licensed architect, nevertheless produces art, and has done so for over 40 years with incredible success and acclaim. The subject of Spain's work varies, but primarily focuses on landscapes – both man-made and natural, and often juxtaposes the two against each other in thoughtful composition.

Perhaps Spain's most celebrated, and certainly most exhibited work, is of Rome, Italy. Spain, an architectural professor, recently retired from the University of Miami, where he had been leading groups of students to the eternal city for almost 25 years. In that time, he helped countless students improve their drawing skills and their abilities to observe and record the Roman landscape of monuments and ruins. It also gave him the time to draw and paint on his own, slowly amassing a stunning collection of pieces that, when seen collectively, tell us a story of the city in his time, just as the great Vedutistas (Giovanni Battista Falda, Giuseppe Vasi, and Giambattista Piranesi) did in theirs. It is the work of Piranesi that most influenced Spain.

Piranesi, himself an architect, worked in a time when papal commissions were scarce and Rome was waning as a dominant political force. Piranesi's Rome is simultaneously glorious and deplorable. The monuments were over-scaled for effect, recalling the grandeur of the past, while the years of neglect were also apparent. The ground-planes revealed the reality of the time, full of trash, vagrancy and offscourings. In Spain's drawings, the ground-plane is curiously omitted. The station points in his perspectives are intentionally low. This has two consequences. First, like Piranesi, it creates an impression of Rome as being larger than life. This may be inaccurate technically, yet appropriate symbolically. Second, it allows him to remove the clutter of everyday life on the streets filled with overflowing trash cans, menu placards and double-parked motorinos. Curiously, Spain's collection of "fine art" pieces do just the opposite. They bring attention to the mundane, thereby critically commenting on the ostentatious. Rome, in many respects, is the ultimate example of this, but somehow deserves pardon from assailment, perhaps because it remains a mecca for architects and continues to be incredibly relevant in architectural education.

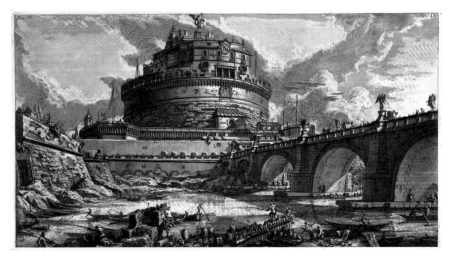

Castel Sant' Angelo, circa 1756, Piranesi

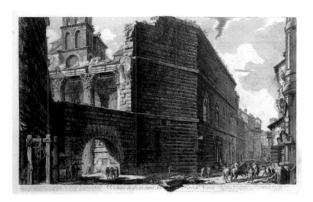

Veduta degli avanzi del Foro di Nerva, circa 1756, Piranesi

The reasoning behind Spain's selection of subject matter in Rome can be understood through the words of Aldo Rossi in "The Architecture of the City." Rossi suggests that the manner in which history speaks through the arts is by way of its monuments – its willed expressions of power. The past, he suggests, is our collective memory, and monuments mark history and provide order to the city. A city's past can be remembered through its monuments. Rome is, by extension, perhaps the most memorable city in the western world. Long walks through the city at night are episodically halted to admire these monuments seen countless times before. Spain captures these moments in time by spending hours sitting on the top steps of neighboring buildings, propping his back up against stone walls, looking carefully as each subject reveals more, hour after hour, year after year.

Spain describes his approach to drawing Rome as still life. By removing the ground plane, he allows himself to arrange the buildings slightly, just as an artist would while drawing fruit in a bowl. He therefore can manipulate the composition to enhance the visual experience and capture the emotion of being there. Over the years, he has drawn the same subjects differently, with different media in different light. Five weeks in Rome, the typical residency

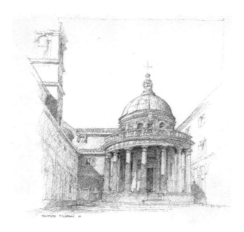

Tempietto, 2001
Pencil

by faculty, is bittersweet. It's long enough to establish a familiarity through routine, but too short to ever remove the fleeting sense that it will be over all too soon. Spain's drawings come from this reality.

Spain is also seduced by the challenge of drawing technically difficult things. He suggests in an interview included in this publication that greatness in drawing is 95 percent practice and 5 percent drive. Spain's drive is to document the architecture of Rome with incredible detail and precision. This informs his own architectural vocabulary and understanding while simultaneously challenging himself to accurately represent the many complex geometries and rich surface textures found in the heroic monuments of Rome. Through careful examination of Spain's pencil drawings of S. Giovanni in Laterano from 2001, or Pietro da Cortona's Santa Maria della Pace from 1991, one begins to understand the appropriateness of categorizing these works, along with several others, as part of a masterpiece collection. Persistence, passion and the self-described stubbornness of Spain collectively contribute to his success. This approach and mindset is manifest in his work, and is ultimately the legacy he leaves behind to the many students he has taught in Rome, and to the countless others his art continues to inspire.

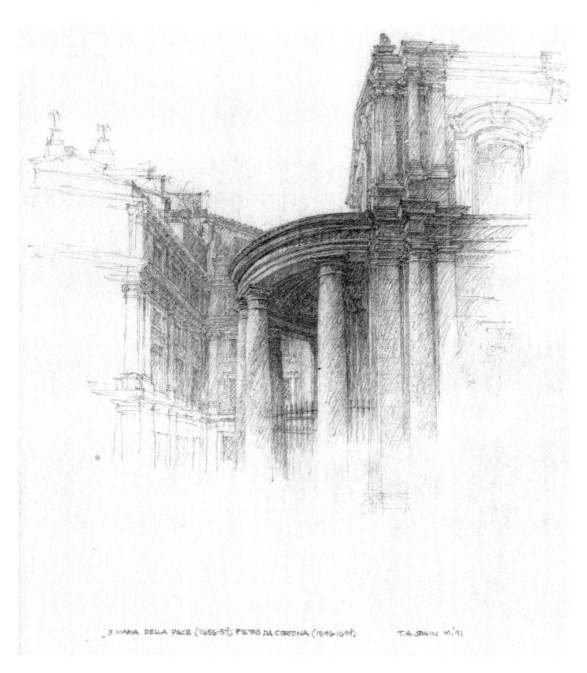

_ S. MARIA DELLA PACE (1656-57), PIETRO DA CORTONA (1596 1669) T.A. SPAIN M.'91

Santa Maria della Pace, 1991
Pencil

Steven Fett

29

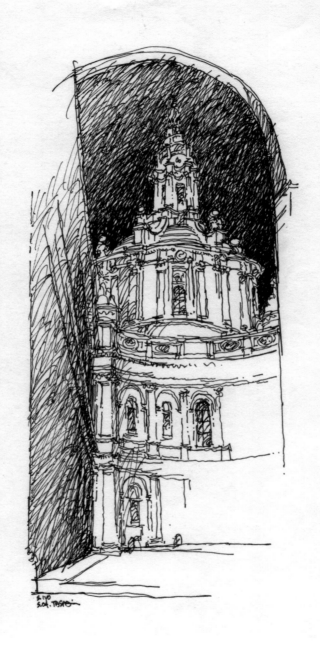

Sant'Ivo alla Sapienza, 2004
Pen

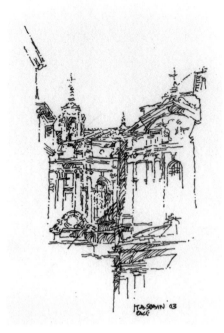

Santa Maria della Pace, 2003
Pen

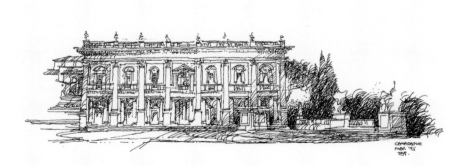

Campidoglio, 1995
Pen

Steven Fett

31

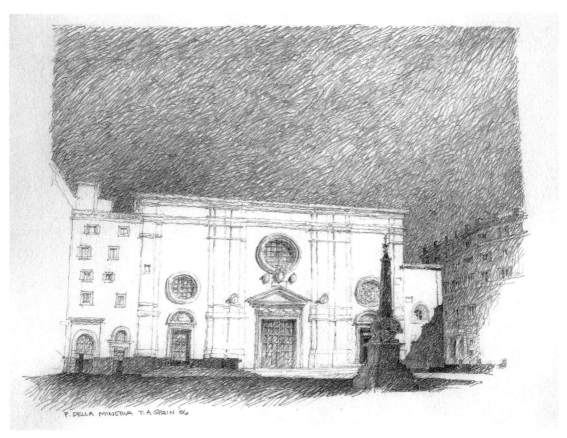

Piazza della Minerva, 2006
Pencil

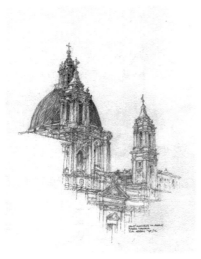

Sant' Agnese in Agone, Piazza Navona, 2010
Pencil

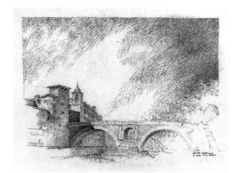

Ponte Fabricio, 2004
Pencil

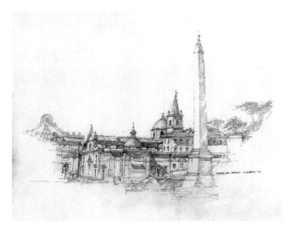

Piazza del Popolo, 2012
Pencil

Steven Fett

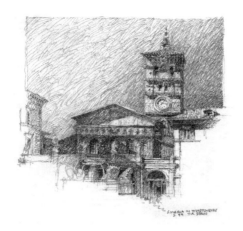

Santa Maria in Trastevere, 1999
Pencil

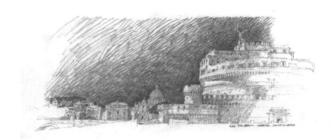

Castello and Ponte Sant'Angelo, 2008
Pencil

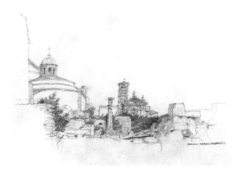

Roman Forum, 2010
Pencil

The Drawings of Rome

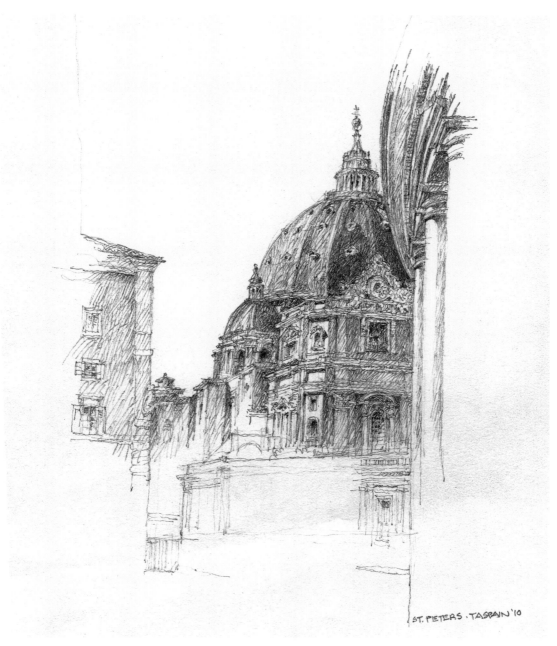

ST. PIETERS · TASPAIN '10

San Pietro, 2010
Pencil

Steven Fett

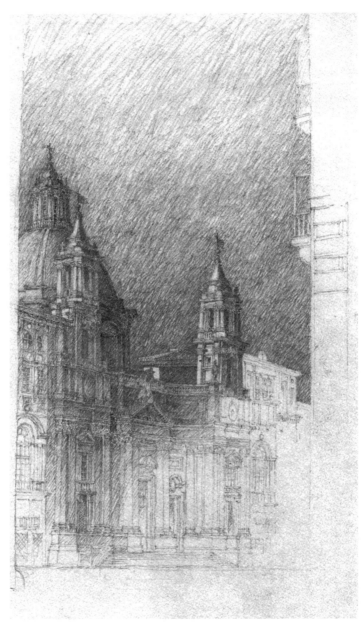

Sant'Agnese in Piazza Navona, 1991
Pencil

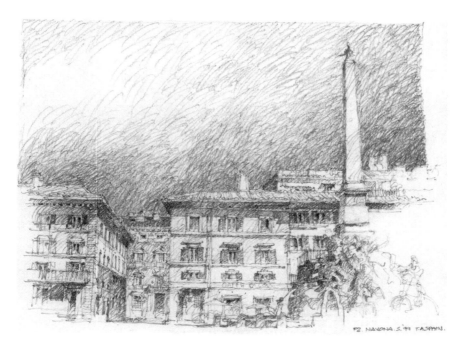

Piazza Navona , 1999
Pencil

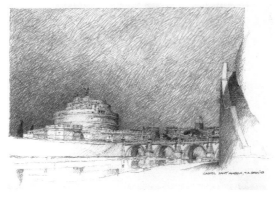

Castel Sant'Angelo, 2003
Pencil

Steven Fett

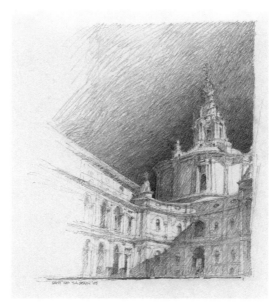

Sant'Ivo alla Sapienza, 2005
Pencil

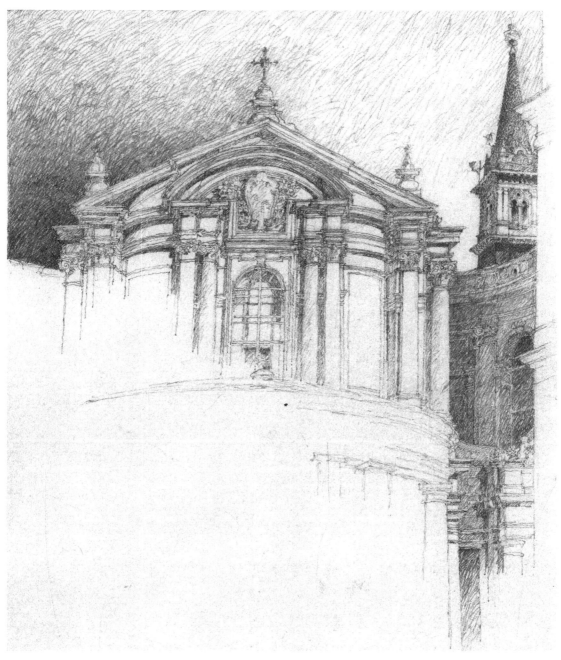

Santa Maria della Pace, 2001
Pencil

Steven Fett

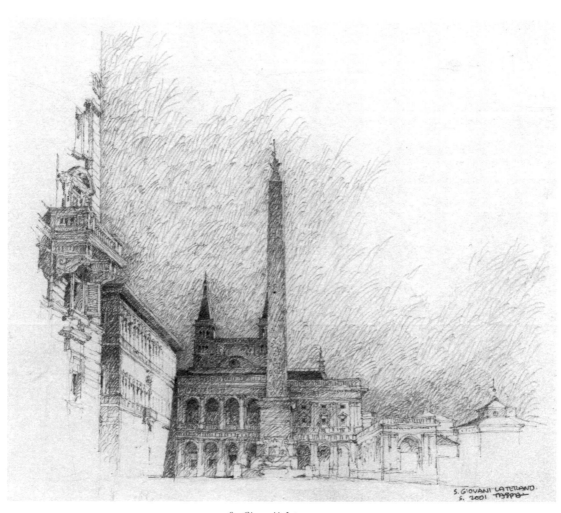

San Giovanni in Laterano, 2001
Pencil

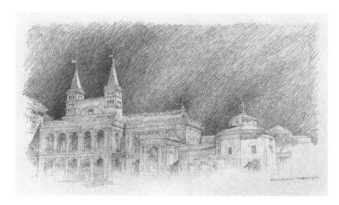

San Giovanni in Laterano, 2010
Pencil

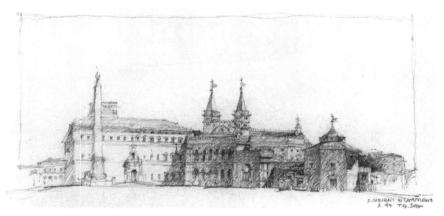

San Giovanni in Laterano, 1999
Pencil

Steven Fett

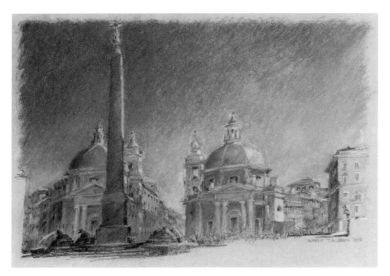

Piazza del Popolo, 2003
Color Pastel

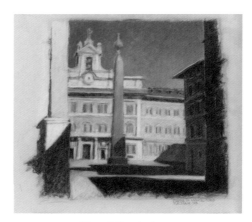

Piazza di Montecitorio, 2003
Color Pastel

The Drawings of Rome

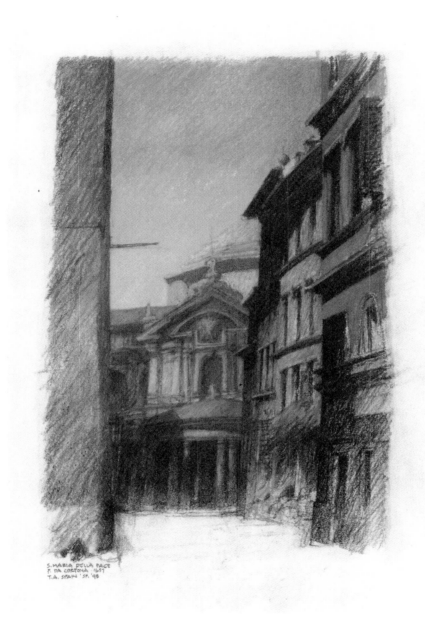

Santa Maria della Pace, 1993
Color Pastel

Steven Fett

43

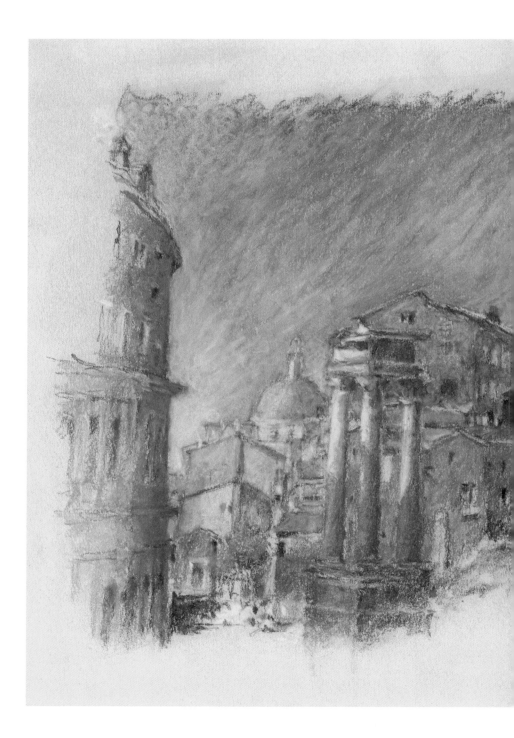

The Drawings of Rome

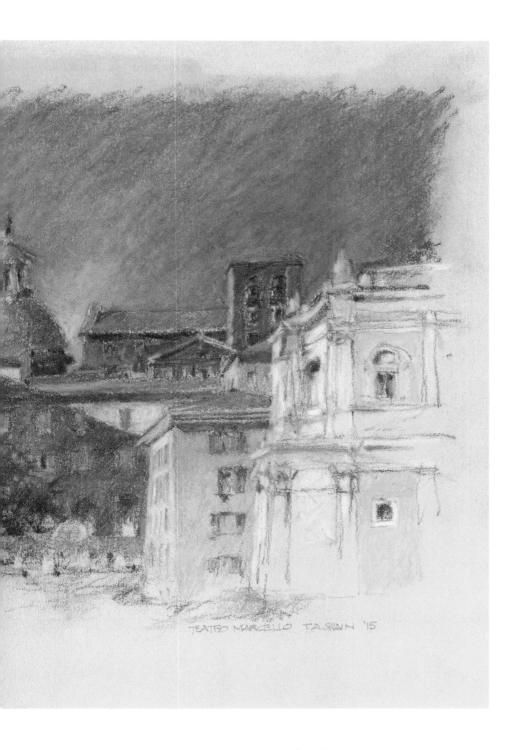

TEATRO MARCELLO TASSIN '15

Steven Fett

45

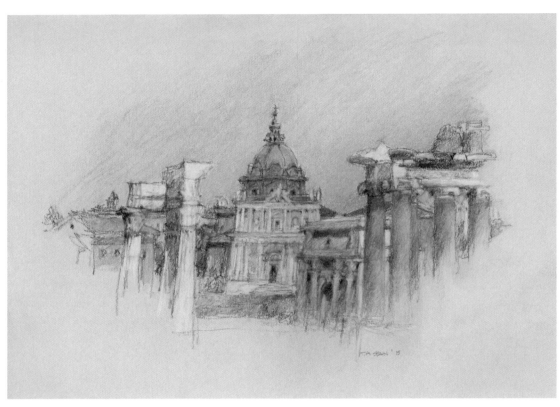

Foro Romano, 2015
Color Pastel

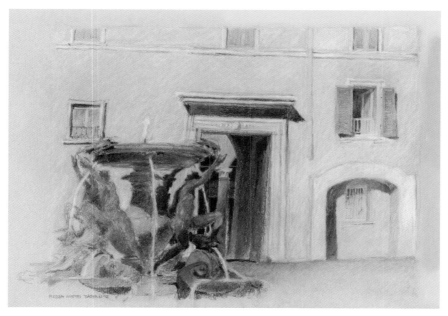

Fontana delle Tartarughe, 2012
Color Pastel

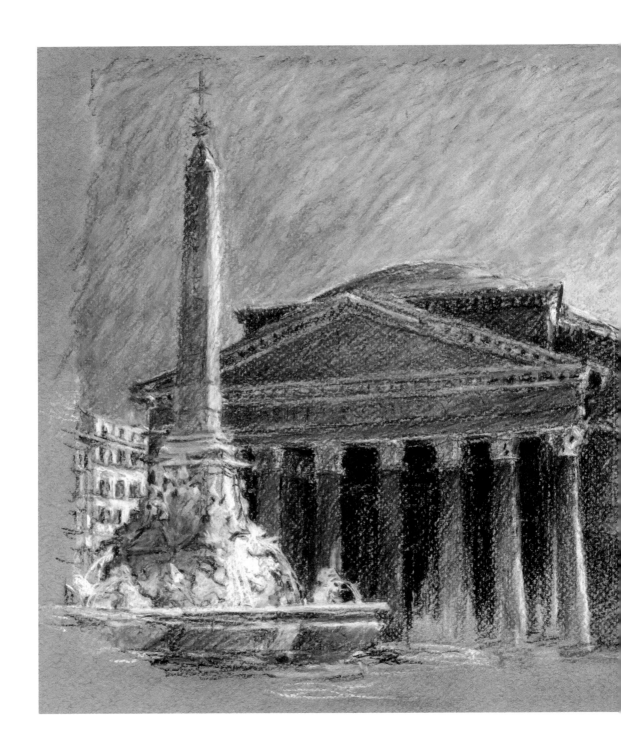

Pantheon, 2005
Pencil

Pantheon, 2013
Black and White Pastel

Steven Fett

49

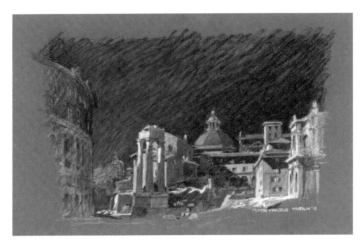

Teatro Marcello, 2010
Black and White Pastel

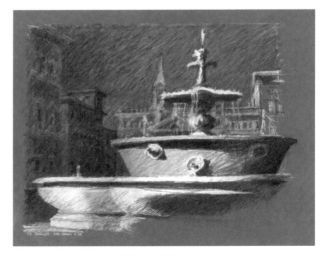

Palazzo Farnese, 2008
Black and White Pastel

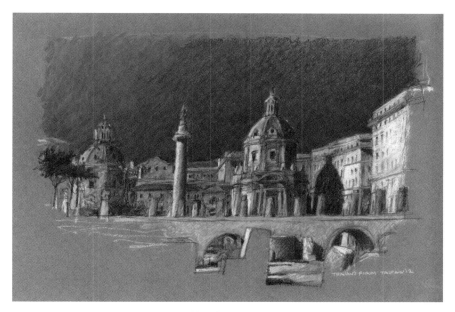

Trajan's Forum, 2012
Black and White Pastel

Steven Fett

Glorifying the Real – Thomas Spain's Coral Gables

By Edgar Sarli

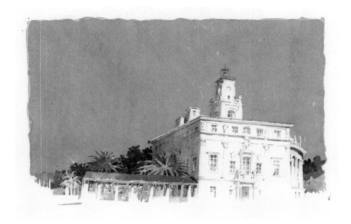

Coral Gables City Hall, 2008
Watercolor

Thomas Spain's adopted home, Coral Gables, has proven to be one of his most fruitful sources of inspiration. It is in his series of partially real, partially imagined views (those he refers to as Capriccios), where the work's ambition goes beyond capturing a place's formal, textural and plastic presence, to become fertile ground to explore personal views on history, ecology, architecture, urban growth and society. Contrary to Rome, where his curious eyes are almost exclusively drawn to the magnificent monuments of the city, in Coral Gables Tom Spain's attention is drawn to the extraordinary as well as the mundane.

He reveals secrets and tells stories. Canonical, fragmented, and sometimes unexpected views of Coral Gables are rendered as stage sets where the theatrical nature of life unfolds. A wrinkled paper bag, a ladder, or a chain-link fence are generic objects that in Spain's daring compositions assume predominant roles and could be understood as protagonists of a frozen-in-time play. The dialectical relationship of the subjects drawn creates a high degree

of tension that sets a unique tone for the author's communication with his audience. Tension, ambiguity and exuberant technical sophistication are only a few of the constituents of Spain's method to engage through his work the most creative corners of the observer's mind.

"Natural Field/Water Tower" is part of a collection of early drawings focused on juxtaposing natural and manmade environments. It offers two distinct readings. On one hand the composition may seem to evoke the symbiotic relationship between the South Floridian landscape and the Mediterranean inspired architecture introduced by George Merrick. However, one may speculate about whether the drawing is in fact a nostalgic representation of the fragility of the indigenous landscape eventually displaced by the inevitable development of Coral Gables and Miami as a metropolitan area. The strong horizontal line defined by the delicate omission of graphite, divides the composition into top and bottom. The city and its architecture, symbolized solely by the verticality of the tower, are blatantly placed above nature. Below, meticulously rendered grass evocative of Andrew Wyeth's paintings, places an equal amount of attention on each grass thread as in the architectural details. Above the horizon, a flock of birds flees the scene. Beneath, the weight of the coral rock displaces the grass. The circular nature of the piece's meaning flourishes; city and nature are drawn with the same amount of intensity and care. The beautiful execution of all the parts accomplish a refined degree of harmony suggesting they are all in great comfort with one another, are they not?

"Everyday life/Granada Entrance" on the other hand, speaks of the friction found in Miami's urban fabric. The composition is dominated by two areas delineated by the edge of a chain link fence. On the right side, and presented as background, the Granada entrance is framed by a square of almost untouched paper. To the left, the layering of symbols characteristic of Miami's anonymous areas counteracts the formal clarity of the gate. The wrinkled paper bag, glorified by Spain's colossal talent with graphite, is twice the size of the gate and dominates the picture plane. Behind it, a chain link fence separates a modest home from the potentially undesirable reality of urban life.

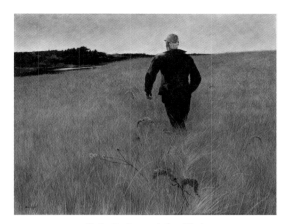

Turkey Pond, 1944, Andrew Wyeth

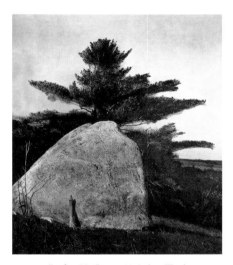

Far from Needham, 1966, Andrew Wyeth

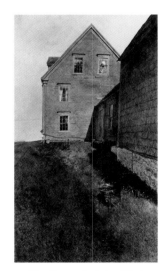

Olson House, 1965, Andrew Wyeth

Edgar Sarli

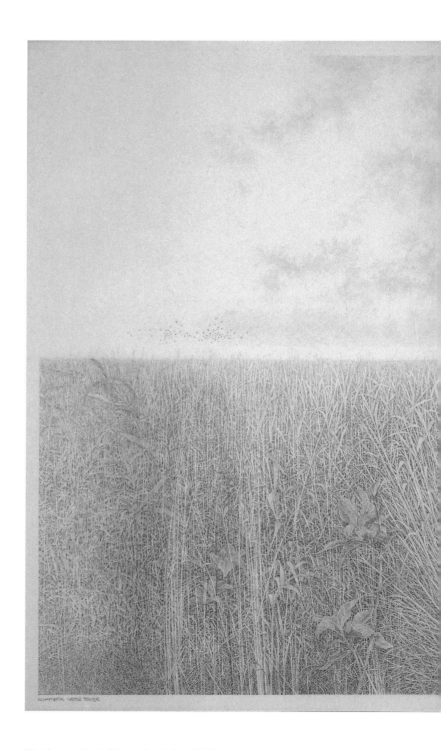
ALHAMBRA, WATER TOWER

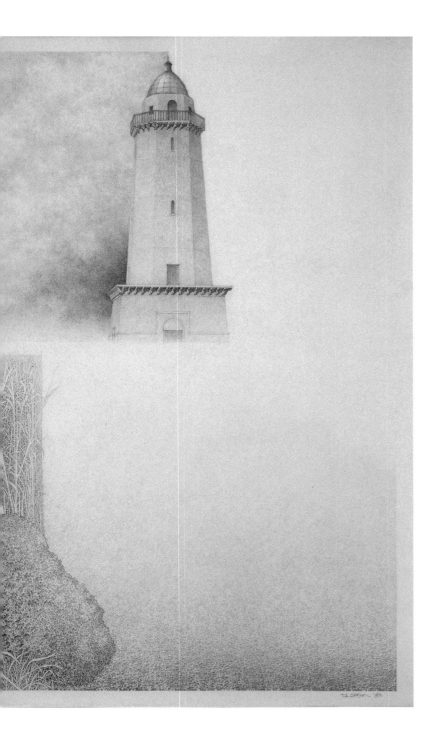

Natural Field /
Water Tower, 1982
Pencil

Edgar Sarli

Study sketches of Everyday Life /
Granada Entrance, 1991
Pencil

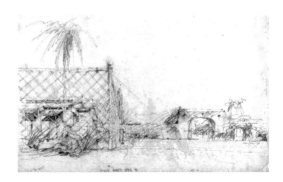

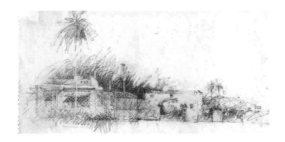

Glorifying the Real – Thomas Spain's Coral Gables

The drawing synthetizes for the viewer one of the unique characteristics of Miami's urban fabric: abrupt transitions within the grid unmediated by any design intention. From this perspective, the drawing can be understood as a map of Miami in its conceptual dimension. Furthermore, the selection and careful rendition of ordinary life aspects reveals the strong ties of Spain's work to Caravaggio's. Committed interest in unidealized reality, found for example in the rotting fruit in Caravaggio's "Boy with a Basket of Fruit," or the pale agonizing face of a young, sick Bacchus in "Bacchino Malato," stimulate a feeling of uncertainty and nostalgia parallel to those achieved in "Everyday life/Granada Entrance."

"Landscape Workers" and "Builders" further evidence Spain's interest in realism and social issues. Caravaggio would paint portraits of the young artists who would entertain the baroque roman nobility in "The Musicians," or would set "The Calling of Saint Matthew" in a Roman tavern with Matthew and his collaborators dressed in the customary outfits worn by lay people at the turn of the 16th century. But Spain's landscape workers and builders are only acknowledged by their utensils and the marks of their work. The setting continues to be Coral Gables, but in this case, there are no monuments. The actual workers who beautify the city on a daily basis are the celebrated ones. Spain would humbly argue he has never drawn a single figure in his entire life, yet through bold composition and strategic omission he is able to represent a collective and its essential contribution rather than the individual and its ephemerality.

"Family Portrait" and "June 6th, 1928" reveal Spain's literary inclinations. Both watercolors commemorate important structures and events in the life of George Merrick. In "Family Portrait" an empty chair located at the center of the lower border of the frame is charged with a high degree of mystery. Behind it, Merrick's childhood home peacefully rests under Coral Gables' warm afternoon sky. The chair is central to the composition but its lower half is cut off from the frame. The scene is set right before or after the Merrick family would have been photographed. No member of the family is drawn, yet their

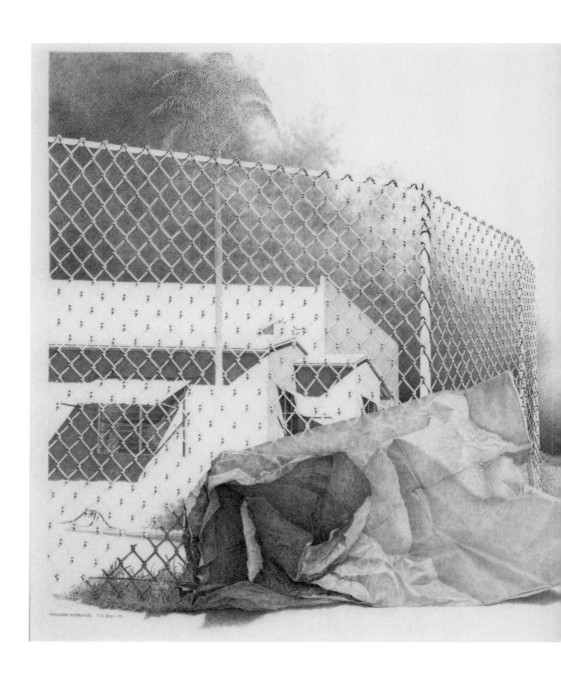

Everyday Life / Granada Entrance, 1991
Pencil

Edgar Sarli

presence resonates. Deliberately omitting the subject stimulates reflection and wonder reaching a level of abstraction reminiscent of metaphysical paintings such as "Mystery and Melancholy of a Street" by Giorgio de Chirico. Equally central to the meaning of "June 6th, 1928" is the figure of George Merrick, although, once again, he is not drawn.

The title of the piece evokes the date when George Merrick was expelled from the Coral Gables City Commission. The painting, a radical one-point perspective where the vanishing point is located at elevation zero and perpendicular to the edge of the City Hall, is carefully composed. The vanishing point defines, to its left, a perfect square containing the City Hall loggia, a recently planted Royal Palm, the City Hall and its clock tower, a ladder leading to it, and Merrick's belongings waiting to be picked up. Spain's work is nostalgic. Not a long time passed since Merrick envisioned "his" city beautiful project, perhaps sitting at the loggia of his parents' house. The moment his belongings were found at the City Hall loggia symbolizes the paradoxical nature of life and is executed dramatically by Thomas Spain.

Coral Gables and Tom Spain constitute an outstanding duo. It is here where his work reaches its highest level of sophistication. Besides achieving the "impossible" with graphite and pigment, a carefully calibrated balance between commentary and documentation transforms the drawings into valuable cultural artifacts. If in the drawings of Rome, Spain is arguably dialoguing with the city in space and throughout time, in the Capriccios the dialogue is unequivocally with the audience. Understanding the pieces requires involvement, curiosity and time. A masterful dance of the eyes is choreographed on the surface allowing the meaning of each piece to slowly unfold.

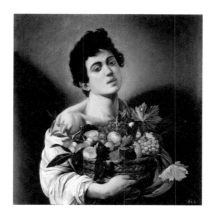

Boy with a Basket of Fruit, circa 1593, Caravaggio

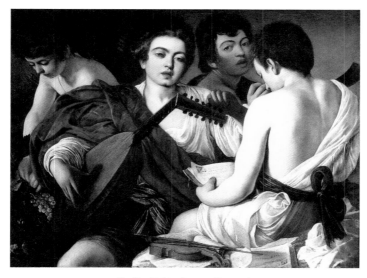

Bacchino Malato, circa 1593, Caravaggio

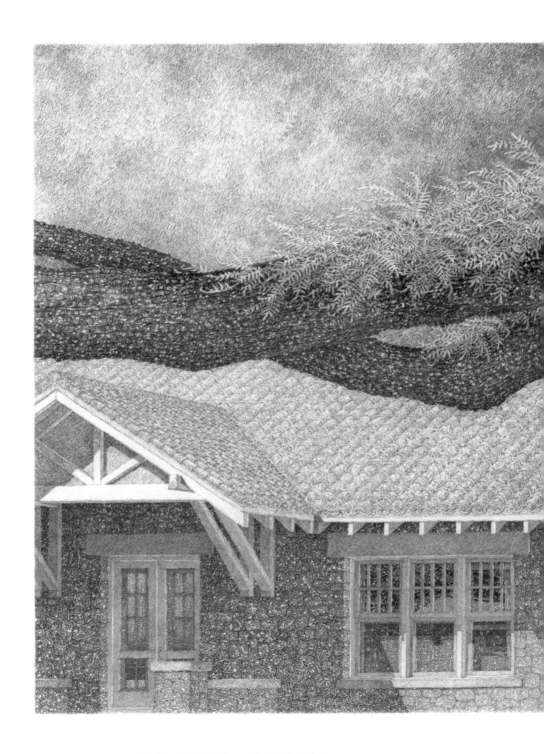

Glorifying the Real – Thomas Spain's Coral Gables

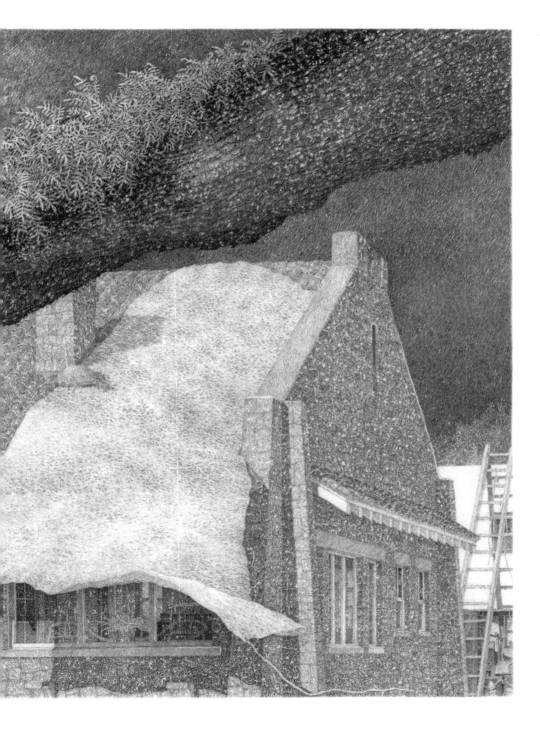

Edgar Sarli

Study sketches of Landscape Workers, 2014
Pencil

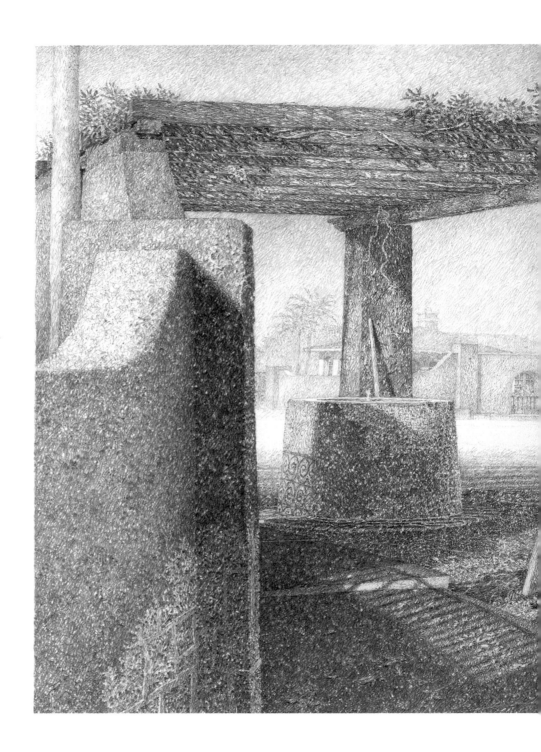

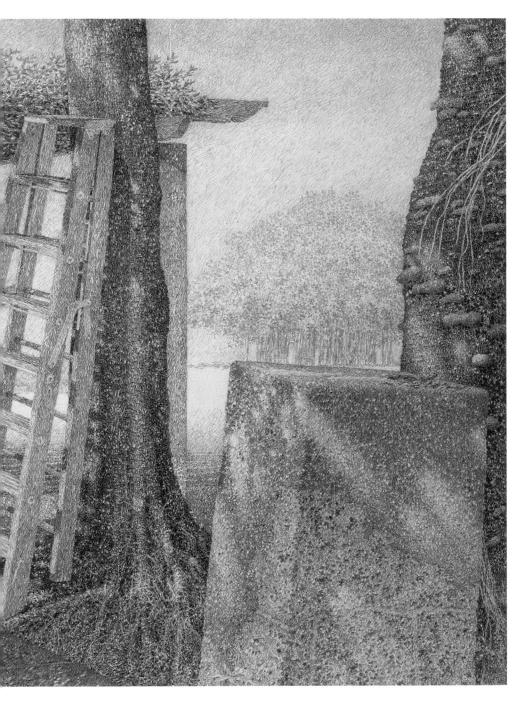

Edgar Sarli

Sketch and Drafted studies of Builders, 2014
Pencil

Edgar Sarli

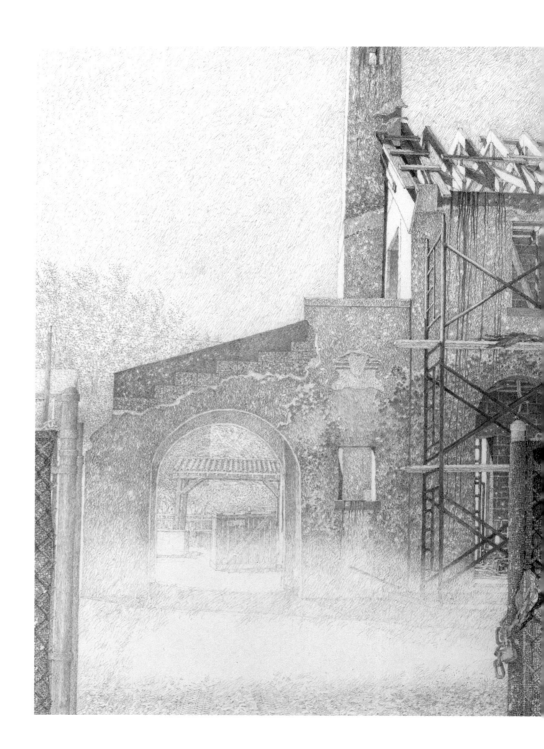

Glorifying the Real – Thomas Spain's Coral Gables

Builders, 2014
Pencil

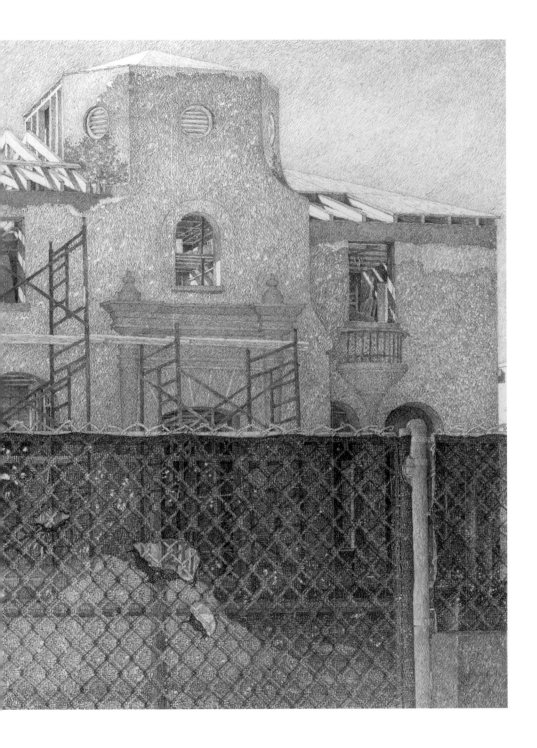

Edgar Sarli

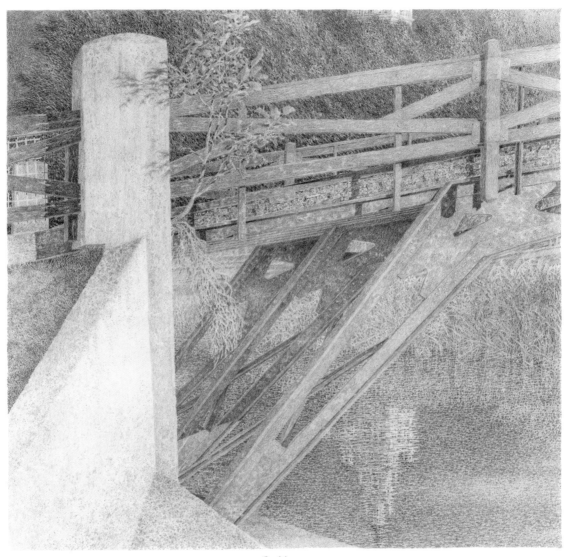

Gondola, 2017
Colored Pencil

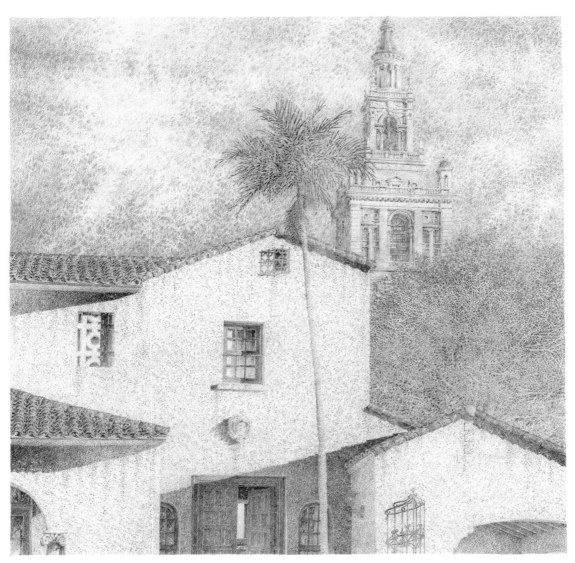

Dinner, 2018
Colored Pencil

Edgar Sarli

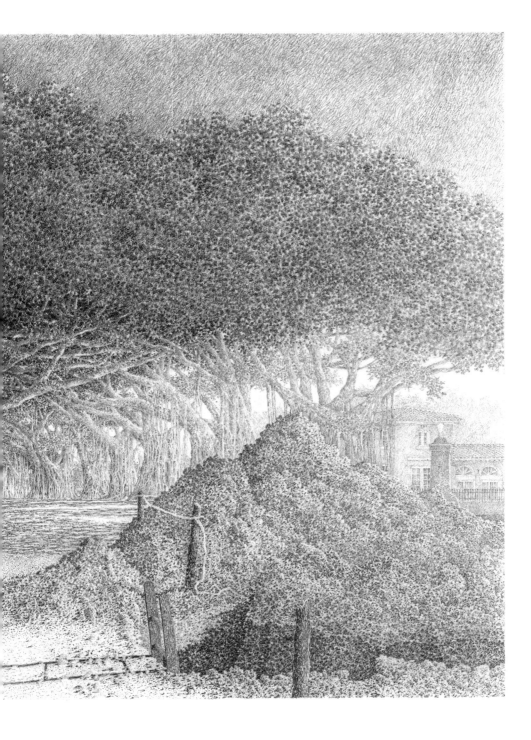

Edgar Sarli

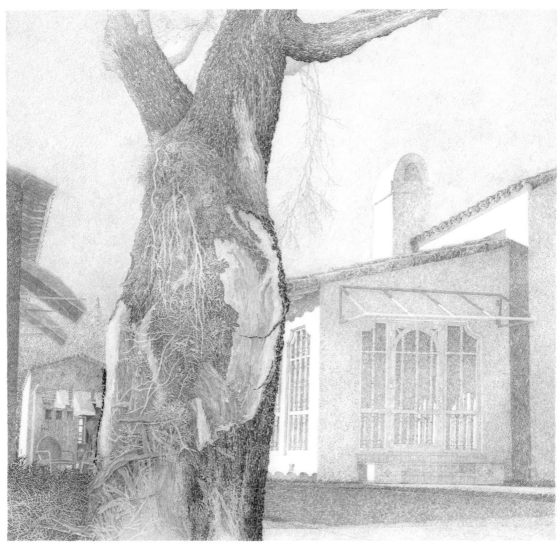

Irma, 2018
Colored Pencil

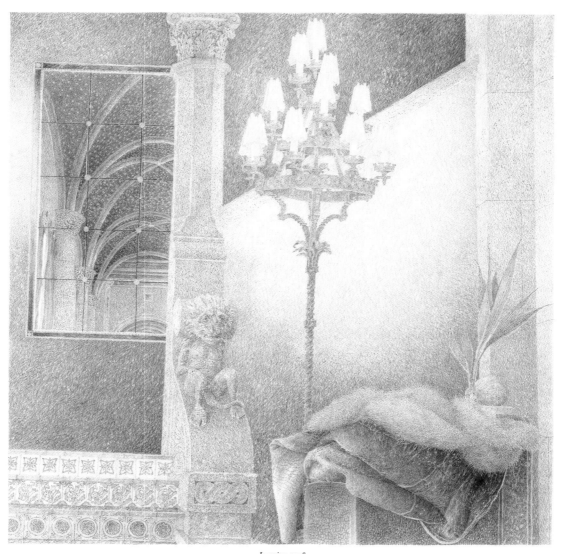

Leaving, 2018
Colored Pencil

Edgar Sarli

A Conversation with Tom Spain, Steven Fett and Edgar Sarli

September 6, 2014 & April 15, 2017

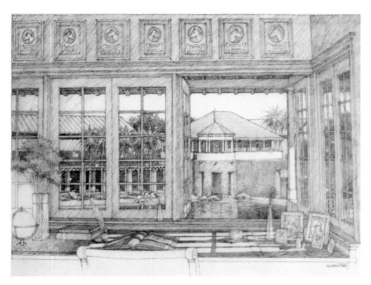

Proposal for a courtyard house, Windsor, Florida. T.A. Spain and Rolando Llanes, 1990
Pencil

EARLY DAYS IN MIAMI

ES: You are a practicing architect whose close relationship with the visual arts makes the division between the two disciplines almost non-existent. Did you study Architecture before Fine Arts or vice versa?

TS: I received my BArch first, then in 1966 Paul Buisson invited me to join the University of Miami as a design instructor. The Arts degree came later.

SF: At that time the School of Architecture was still part of the School of Engineering, correct?

TS: Yes, it was, but it was already evolving out of the Architectural Engineering program. I was one of the only three or four design-oriented faculty in the program. Back then, the emphasis was placed on structures, and materials and methods courses. Architecture and engineering students took engineering

Martinez Residence, T.A. Spain and Rolando Llanes, 1991-92
Pencil

courses together. To get an architectural degree, one had to get through the structures sequence with the civil engineering students.

ES: Plus design studios every semester?

TS: There were fewer, but they were trying to introduce a fully accredited architecture degree curriculum, which Paul had designed. They brought me here to teach design as an instructor, and I liked it, but even then, I knew I needed another degree in order to do it for a living, so, I worked towards the painting degree, because it was something I could do while I was teaching part time.

SF: That was a Master of Fine Arts?

TS: It was a Master of Art. Fine Arts had other requirements, but I don't remember what they were, and I didn't do it. I started it in Miami in the Art Department. Initially, they didn't want to let me in, they said, "What are you doing here, you're an architect?" I showed them my transcript, and I had as many studio courses in drawing, art and sculpture as their students. In my Bachelor degree, we took a drawing, painting or a sculpture studio almost

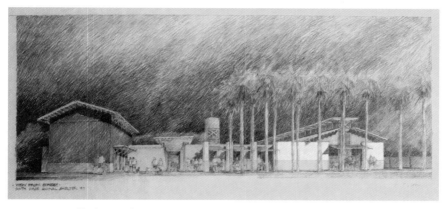

Sketch proposal for the South Dade Animal Shelter, T.A. Spain and Rolando Llanes, 1997
Pencil

every semester. It was the old Bauhaus curriculum, no materials and methods. It was very low on technology, very high on art. I opened my trunk and I showed them almost 10 paintings that I had been doing. I always painted. So, they let me in, and I started the degree. Before I could finish, I was drafted into the Army during the Vietnam War.

SF: When you say: "They brought me down to teach in the program," how did that work? Were you living in North Carolina at the time?

TS: I had just graduated. Ken Haggard was teaching at UM, but he was leaving to do graduate work at Penn, so Paul said, "Go back to Raleigh and find somebody to replace you."

ES: They didn't know you?

TS: Well, Paul knew me. He had taught at NC State, but got into an argument with the dean, and came here. He liked fishing and being next to the water, so he moved here. Paul was a very good architectural historian and a great designer. He sent Ken up there and I met with him. He asked me what I was planning to do when I graduated. I told him I had no idea and that I'd prob-

ably be drafted. He said, "Maybe you should come to Miami to teach." I was contemplating joining the Army or the Peace Corps, you know? What do you do with your life under those circumstances.

SF: How old were you at the time?

TS: Regular age. One year older than the average BArch graduate. I was 23. I met him when he was teaching at NC State. He had run a competition for the sophomore class. Although he wasn't my teacher, he was the coordinator for the entire class. I didn't know him, but he remembered my project, and he had thought it should have won. Truthfully it was not a very complicated process. They called me on the phone and said: "Do you want to do this?" and I said: "OK."

ES: Had you ever been to Miami before?

TS: Never.

ES: Did moving to Miami sound like moving to a remote frontier town?

TS: It did. It was a tiny southern town in the sixties, and UM was a small, struggling campus.

SF: We've come to know that the School of Architecture in Miami has an identity that is associated with drawing. What was it like when you arrived?

TS: There were no drawing courses. We required the students to take a couple of classes in the Art Department. Even the mechanical drawing was taught by a separate department called Engineering Graphics.

ES: Were you only teaching design at that point?

TS: Yes, two design classes. The classes were scheduled for three hours Mon-

day, Wednesday and Friday mornings, and three hours Monday, Wednesday and Friday afternoons. There was a time when we taught two design courses plus a drawing course each semester.

SF: When was drawing introduced to the curriculum?

TS: I don't remember. Over time we gradually began to recognize that there were things that we could do, I don't want to say better, but things that were more applicable for architects. The bulk of the courses were taught by other departments. Over time we began to drag those courses into the school.

SF: When you arrived, how many faculty members were in the department?

TS: Maybe eight.

ES: When you were drafted, was the school still part of the Engineering Department?

TS: Absolutely.

ES: And when you returned?

TS: It was still part of Engineering. The school began to grow and soon we had over 300 students. The differences with the engineers increased and we began to talk about being an independent school. In fact, there were only a few architecture departments in the country that remained part of an engineering school. Many schools went through the process. Georgia Tech and NC State both started out as Architectural Engineering programs, and then gradually broke off and became stand-alone schools. This was a common process. So, we began to lobby and the accrediting committee helped. We had accreditation visits. We failed the first one, which wasn't uncommon, but they helped us.

We also had outside help from the profession, alumni and people with accrediting backgrounds. But it finally happened when Tad Foote became the University president. His provost was from the School of Music, and John Steffian was able to talk to him as an artist speaking to an artist. He found a sympathetic ear with the provost. The president, who had just started, wanted to put his mark on the institution, so the move fit his agenda. All the things came together and they made it happen. Steffian had to have a lot of courage. He had to go to the provost and convince him that this should happen. It was his last year, so he went in as an existing department chair and said, "This is not for me. This is what the school needs." He made it happen.

SF: In what years were you in the service?

TS: I was an instructor at Miami in 1966 and 1967, then I accepted a position at Ohio University in Athens. As I was packing my Volkswagen, the chair of the department called me and told me that the provost had just shut the program down! I was literally packed and ready to go and teach in Ohio. I had gone up for an interview and sat in reviews. That was the more normal interview process back then. Unfortunately, I had already gone to Raleigh and found my replacement in Miami. He was already here. So, that year I stayed in Miami. I taught part time, but was primarily a student. I was a student teaching part time to eat! Then I got drafted. I was in the service from 1968 to 1970. After that, I came back to finish the Master in Art degree. I had only a few courses left and I wanted to finish what I started. At that point they had already hired a new chairman for the school. I wasn't a big enough gun for him, so he didn't offer me a full-time position. I think I taught part-time for two or three years. Eventually I finished the Master of Art degree, the chairman left, and the economy took a downturn. I went back to the acting chairman, who I knew pretty well, and asked to be back on full time, and he said, "Sure." That was in 1975. By then, I had done a lot of things. I had painted and I had been a partner in an architectural firm.

HARVARD

ES: You went to Harvard much later?

TS: After I was a full-time part of the faculty again, I thought I would raise a family and have the sort of normal life that everybody has. I did a little bit of consulting, and I also started some of the "fine art" series drawings. I would work during the days and do those in the evenings.

ES: Which drawings specifically did you work on?

TS: The early ones were the ficus tree, the Venetian pool, and probably the fence. They all go back to that era. I went to Harvard when I did, because the timing was right. I had never taken a sabbatical. My kids were already in high school and college, and I was a little cooked on teaching. So, I thought, what am I going to do with my sabbatical? At the end of the day, I'm not a traditional scholar, so I thought it would be fun to see how it was on the other side of the table. There is a bias for having a doctorate or a Ph.D. on campus. Not having a doctorate is awkward. They call you "Doctor" even if you're not. I wasn't interested in the Ph.D. because they take too long, but Harvard had a doctorate, a Doctor of Design degree. They still do, which supposedly takes two or three years. I took the sabbatical thinking it would be sort of life enhancing to have the Ivy League academic experience, which I had never had, and I thought that going back to being a student would be liberating. So, I took the sabbatical year and started the Doctor of Design program.

ES: In what year was that?

TS: In 1990.

ES: Who was the Chair of the Architecture Department at Harvard then?

TS: Rafael Moneo. I did it for a year. I decided what I wanted to do for my

dissertation and I started doing the research. The program had been around for about five years, and they had not given anyone the degree yet. I talked to the people who were doing it, and for all of them the work was stretching out just like a PhD. Well, I had kids, and I was almost 50 years old, I said, "Thanks, but I can't do this for that long." They wanted me to come back, do my research, and become a teaching assistant. I only had one year of sabbatical, and I didn't want to take a leave. They were nice about it, thankfully. It was tuition free, and at the end, because of the one year, they gave me an M.Des., a Master of Design. It was difficult for me because I'm a designer, a painter and a drawer, but there, I had to write a paper every other week. I wasn't taking any studio classes. I was taking only lecture courses. It was torturous! I'm not a great reader, I'm not a great writer, but there all day, every day, every night, I was reading, writing and taking notes. It was a stretch, but it was also a good experience.

ES: No time to draw?

TS: None. By the second semester, I ended up finding a solution. They let me take one course anywhere in the university, so I found a little course in print making. Oddly enough, Ernesto Buch was there at the same time. Douglas Duany and Teofilo's (Victoria) sister-in-law, Gina, was also there. The three of us all would joke about the fact that we were reading and writing all the time. A few of us ended up in that print making class. It was like a life saver. We could get a break and spend time with the people we knew. Harvard is a fairly alienating place. You don't make life-long friends. Boston is also an alienating town. Sometimes I would realize on a Friday that I had gone the entire week without speaking to anyone. I would go to class with kids. I would take my notes, go home, read and write, but I hadn't interacted with another human being other than a waitress for the whole week. It was dark and cold on top of that. But, in retrospect, it was good. I could backtrack and fill a lot of gaps that I had, mostly in history and theory. I didn't get to study what I wanted to, which was focused on compositional issues. That's still what I want. If I ever write anything, it's going to be about composition.

COMPOSITION

SF: Could you elaborate a bit on the particular aspects of composition you're most interested in?

TS: Moneo once in a lecture said, "Composition is nothing." I almost jumped up. I couldn't disagree more. I think composition is everything. I think it's almost everything in life, frankly. For me it can generally be broken down into two parts. First is the selection of the parts. It is like making a movie, writing a story, making a building, making a drawing, or having a life. First you have to choose the constituent parts of the composition. Selection is almost never talked about. With some painters, it is completely obvious. For instance, in Vermeer's case, those rooms don't exist in the way he painted them. He carefully selected a chair, a tapestry or map on the wall. He selected the girl. He selected the hat on the girl. He selected all the pieces, and he carefully composed those pieces. Although they've never been found, there had to be many compositional studies.

So, first you pick the pieces, and then you arrange the pieces. There are guidelines. There's a language that you can use to talk about composition. There have been a few writers who've talked about it. Gyorgy Kepes was one. I'm not sure where he taught; I think at MIT. He wrote a book called "The Language of Vision." I use it in my teaching and in my work. There had been others who wrote on the topic, but not in a way that's easy for students to use, in my opinion. In my watercolor classes, in Miami or Rome, I tell the students the most important decision you make is where you choose to sit. That means everything as to whether your drawing is going to be valuable or not. You choose to sit in a specific location because there's an arrangement in the visual field that you find interesting -- either poetic or dramatic.

The cubists had one set of compositional issues, and clearly Raphael had another. Rembrandt had another set. Rembrandt is interesting because he played with many different compositional arrangements. He played with

circular organizations, and he played with the focal point. The religious painters always placed Jesus in the focal point. If I were to summarize it, I think what you're doing when you're composing is manipulating the way the image is consumed. You are moving people's eyes in a particular way, and I think the best paintings are those where your eye does a kind of dance over the surface of the painting or the space. You move from place to place. You make long moves. You make short moves. You stay in one spot longer to consume more detail, but in the end, the best paintings are very much like a dance. I have a strong bias towards triangular dance patterns. If I am doing it right, there are three focal points. That's my intention. I want to move your eye in three ways, from spot to spot, and then you sort of move out into the details. But for some reason, I rarely pull it off. I don't know why; it just doesn't happen, but that is always what I want. I like to sort of stretch those triangles.

ES: When composing a drawing, do you think of the location of the focal points as a way of structuring the paper, and then the textures accompany the movement of the eye? Is there a first step?

TS: No, I just think it is all done by experimentation. I just play with it until it feels right.

ES: In the case of the compositon of your Venetian Pool drawing, if I draw an angle where the sun is I seem to get a golden section, a square with a golden section on the left, is that something that happens consciously?

TS: In those days, it did.

ES: It did, so you were you laying out that grid, golden section here, square here?

TS: No, I don't measure. It's more of an intuitive thing. I think all architects have it. You don't actually need to draw a golden rectangle, because if we miss by this much it doesn't really matter.

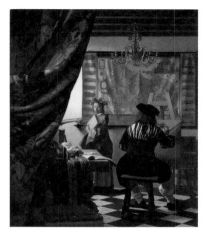
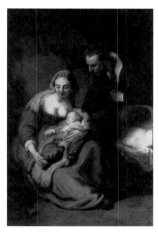

The Art of Painting, 1666, Johannes Vermeer *La Sainte Famille, 1635, Rembrandt*

SF: So, it's not something you draw, but you explore it when testing your compositions?

TS: It's not something I do consciously, but it's something I chase if you look at all the preliminary studies. Also, I am not sure that is a good thing. I think it's a good thing in architecture, but I keep wanting to break it in the paintings. If you look at the great painters, they will often make subtle shifts to create more interest in the composition. They don't want them to be 100% composed. They will kick them out of balance and give you a little surprise. It's one of the reasons I will occasionally push everything close to an edge. A good comparison is between Bellini and Titian, both Renaissance painters. Bellini's work is awe inspired, but it has a different type of energy and emotion than that of Titian's. Titian brought real compositional tension into his paintings. I keep saying I need to do that. I just don't have the guts to do it, or perhaps, I am too much of an architect.

ES: The use of paper -- plain, untouched paper -- seems to be an important compositional element for you.

TS: Yes, figure-ground. I think that is also very architectural. As an architect, you're naturally preoccupied with the residual space. You manage the open spaces. It's not just me, all of them do that. As an architect, you have to think about it.

SF: In the case of the Venetian Pool drawing, the untouched space is even more important to the composition, as it divides the drawing in two.

TS: Yes, the compositional, or intellectual focus of that drawing, which is in theme with others in the series, is the contrast between the natural and built worlds. The contrasting element is the sunlight, burning out the middle of the drawing. The sun bisects your view as it reflects off the water. It's also a compositional trick because it allows me to bring the edges a little bit closer together.

SF: I would argue that is helps to exaggerate, and brings to the attention the vastness of the pool itself. It historically was, and still is, one of the things that's impressive about it. Here, it depicts something beyond just a pool, it almost appears as an arrival at a new, magical place. Perhaps as it would have been seen in its earliest days, when it was alone in the landscape, prior to the city that grew up around it.

ES: It's almost like an illusion in the dessert, a mirage.

TS: That's interesting. I like that. The place is picturesque. It's also one of the most impressive pieces of artifice in the state, maybe even the south, and you should completely accept and appreciate it as that. It's the equivalent of putt-putt golf. It's Disney 50 years before Disney built the ultimate artifice, and it's the ultimate picturesque success. I have a hundred study sketches, I thought that I could easily do a series of five on the venetian pool, because no matter where you are, there is something interesting to look at. It sets up so nicely. I don't know of any other examples that work as well. The closest one I can think of is the Ponce de Leon hotel in St. Augustine by Carrere and Hastings. It's now a catholic university.

TEXTURE/REFERENCES

SF: Where do you typically start a drawing?

TS: Right to left, which is exactly what you are not supposed to do, but I can't help myself. You're also supposed to work from top left to bottom right, and I work right to left. I know it is going to cause me grief, but I can't help it. You mentioned textures and surfaces. I'm intrigued by complexity first. I'm not a distiller and I'm not very much of a modernist in the end. I like things to be very rich and complicated. I like it to be a big meal for your eyes. I also like the challenge of trying to pull off a complicated texture. There's the belief that surfaces lie to you. Modernism is about getting beneath the surface because that's where the truth is. So, you're always supposed to be scratching your way through the surface to get at what's underneath. What I do is a direct and deliberate contradiction. I think there's a monumental amount of truth in the surface. I think that's why I get into it so much and include so much of it in the composition.

ES: Is this something discovered through your own work, or perhaps through the study of the work of others?

TS: Probably through (Andrew) Wyeth. It's through other painters, the painters that I like, Caravaggio with the horses, and Dürer. I'm drawn to the guys who also must have had similar thoughts. I mean, Dürer painted every hair on the rabbit, right? Wyeth painted that entire field of grass and those unbelievable rocks. So, I think I just came to it through affection I found in the work of other artists.

ES: Now that you mention Caravaggio, his compositions tend to be organized around very strong diagonal lines. The triangular compositions you mentioned earlier come back to mind.

TS: Right. Wyeth's compositions also have strong triangles. I don't like the

classical compositions as much. I find them a little static.

SF: How much is your interest in surfaces and drawing things at a heightened level of detail, such as the chain-link fence in "Everyday Life/Granada Entrance," is for the challenge?

TS: A lot of it is the challenge. The chain-link fence is an easy one in comparison to some of the others. The field of grass, the coral rock, and the Ficus tree were more difficult. I'm chasing another one now. I've always been interested in the resurrection ferns that grow on the oak trees. I think I am going to tackle that, just to see what happens. I'm curious to see if I can pull it off and turn it into something. What I am finding out, is that it's one thing to pull it off technically, but the other challenge is to infuse it with some art and poetry. I haven't been able to do this except for the ficus tree, which I think, for whatever reason, is artistic and poetic. To just reproduce it in a photorealistic way is not very interesting in the end.

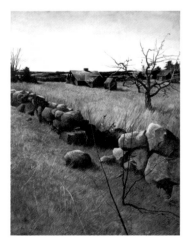

The Stone Fence, 1946, Andrew Wyeth

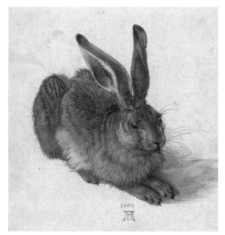

Young Hare, 1502, Albrecht Dürer

ES: Have setting such demanding challenges yielded many failed attempts?

TS: I am such a grinder, and I am so stubborn. There was a guy visiting this morning who said. "This room is very poetic. It's amazing." I said, "It's a poem about stubbornness and patience." Primarily it's a poem about persistence. There isn't much else. It takes a lot for me to give up. There aren't many "throw aways." Particularly with the pencil, you can pull it back to nothing and try again, until you get it.

GIFT OR SKILL?

SF: Do you think drawing and painting are learned disciplines, or do you think it's something you're born with?

TS: I think it's like any other skill. It's 95 percent work. The thing about drawing is that in the broader culture it's accepted as a gift, whereas, great musicians, when you hear them, for some reason, you recognize the work that went into it. Our culture seems to understand that those people practice all the time, and started young. I didn't. I didn't really start drawing until I was older. If you look at the drawings I did when I was in college, the average student here (at UM) does better. Many of the kids in Rome had work that was far better than the work I was doing at their same age. So, I'm pretty convinced that the last 5 percent comes from a lot of other sources. I think blues musicians must have had suffering in their lives to get to the blues. Michelangelo started very young. He did it all day every day, so it's no surprise that he became great. But, when it comes to the extra 5 percent if you would have taken anybody and put him into that position, would he have been Michelangelo? Probably not, but they would have been good, so there is another ingredient – a complicated set of ingredients, probably the primary of which is drive.

SF: Maybe it's passion?

TS: Yes. Passion. To get to the top level, people have to be smart, intellectual and thoughtful. They have to be all those things, but mostly driven.

TS: By the way, I'm not all that driven. I'm not looking for that top 5%.

SF: But to draw that chain-link fence, the coral stone, or the ficus tree requires a certain drive, doesn't it?

TS: You're right you have to be a little bit driven. My drive is to give value to a day. If I draw and I move a drawing forward, then that day has significance for me, and if I don't do any of that, then the day is a little wasted. Mostly, I'm pushing the rock.

SF: Every time we've come over to visit you, you've been at your desk working. You could have been outside playing golf on that course right there.

TS: I played yesterday.

SF: Touché.

TS: No, but seriously, that's true of a great chef, and it's true of Tiger Woods. He's a perfect fit. He's driven and he started playing as a child. He works at it constantly, and he's good. I don't care what it is, like most things, it's skill based. Oddly enough, architecture isn't skill based is it?

ES: I think there is a sensibility one can develop.

TS: Yes, but it isn't performance based. You don't have to do anything. You can be a great architect and only direct someone else on how to do it. Interesting isn't it? I also think success as an architect is a different formula. I try to explain to students what I think that formula is. Oddly enough, the primary factor is still drive.

COMPUTER / HAND DRAWING

SF: You've been a part of the school for a long time and you've seen the school grow and change. It started in the School of Engineering and evolved into a school of architecture that devoted more and more time to teaching drawing, and eventually emerged into a school that is known for drawing. We've come to an era where the computer has become a larger part of the instructional methodology. What do you think is really important to keep in the drawing curriculum as we move forward, and what do you think is not that important?

TS: I wrote a paper about it for the committee. I wouldn't sit on the committee because life is too short to sit on any more committees. I'll see if I can boil it down. I think the value of hand drawing is two-fold. One is that it feeds your personal encyclopedia of responses to given design challenges in a way that nothing else can. That's why I think that almost all good architects had sketchbooks, because to take a photograph of something is not the same. It doesn't register in the same way. If you see something that's good and you draw it, you'll remember it, and it will register in a way that's unmatchable. The more you draw it, the better you'll remember it. I sit in Rome and I draw. I sit down and see something -- Borromini or whatever -- and I think I see it and I draw it for a half-hour. Suddenly I see things I didn't see before. I draw it for another half-hour and more things appear. I've drawn for six hours and looked up and saw something I failed to see, so I really do think the drawing is a way of taking veils off the experience of seeing. It's fundamental. That's point one. Point two is when you sit down to design and you have an idea. It's hard to know whether it's going to be good or not unless you have some frame of reference already in your mind of what is good. So hand drawing, drawing in Rome and drawing in Coral Gables, is absolutely essential for that. I call it the encyclopedia of architectural goodness. I think drawing probably works a little better (than the computer) in terms of teaching the rules that govern the visual world.

Once I was asked to teach a one-semester graduate drawing class. I did it for two years, when the graduate program was just emerging. I started with the

physical reality of things. I'd have them build a form, take it out in the sun, and have them draw it freehand first. I'd talk to them and explain what's shade and what's shadow and how the sun moves. The free hand drawing was the beginning of a conversation about visual experience. After that, I'd take them into the studio and show them, mechanically, how to take that three-dimensional experience and turn it into a two-dimensional experience. Even perspective drawing is real. As things get further away from you, they get smaller. I use the eye as an example, because it projects a tinier and tinier image on your retina. It's a way of managing diminution. So that's the reason to free-hand draw.

The last thing that plays into graphics is time. I'm a firm believer that the subconscious mind is better than the conscious mind when it comes to design decisions. The problem of design has to be framed by your conscious mind, and this might simply be by trying it one time. Then once it's framed (take a design project for example -- a house or whatever) you try it one time, and that puts the subconscious mind to work. Often you have to get out of the way to let the subconscious mind work. You've all done this. You grind away. You sit at your desk for two weeks. You look at books or magazines. You do everything you can do with your conscious mind to solve it, and then when you get up to turn the lights off and leave the room, your subconscious mind turns on and says "hello dummy," and it lobs the solution to you. If not there, it's in the shower, or when you're waking up. Your subconscious mind says, "here it is."

To me, it literally feels like it's being lobbed up into your brain. I've had times where I'll be in the shower thinking of nothing, and the subconscious will give me an answer to a question I asked it six years earlier. It was something I quit on and said, I'll never figure that out, and there it was giving me the answer. Even if you give up, the subconscious mind is grinding away, or waiting for the right time. Things like stippling, poche and hatching were actually useful in an odd way because they gave you a chance to settle down and relax.

Now I say that, but I'm also completely in favor of the computer. I don't think there's any reason that anybody needs to draft again. I think at the end of the

day the quality of the design is directly related to the quality of the simulation. Bernini had them build full-scale mock-ups of the columns and entablature at St. Peters. That's a pretty good simulation. He could say, "No, a closer together here, a little bit fatter here." I also think that's why the Parthenon is so fabulous. It's because there were so many other temples that they could visit that were basically going to be the same. I'm convinced they built full scale simulations of the temples; there was no other way. There's no other way to rationalize the way they made those subtle, perceptual judgments without pretty good simulations. You just can't get that on paper.

ES: It can't be done abstractly?

TS: I think you have look at it. The computer is a brilliant simulator. When I taught design, I'd have them drop their computer models into a photograph of the real site. Instead of having to critique their scratchy little drawings, and having no idea what's in their minds, you suddenly have a brilliant simulation of their solution, and the quality of the critiques became significantly better. Keep in mind, I'm so accustomed to working with trace and doing overlays that I couldn't give crits on the computer screen; I'd make them print it out. You can't draw on the screen.

ES: What I think is very telling about your comments is this meandering conversation between the conscious world and the unconscious world and I think the computer doesn't give you that possibility. When I see your work, especially the fine art series, they seem like meditations, exercises, mantras, and I understand somehow that you're going into the subconscious world when you're doing them, and perhaps the computer is too quick. The subconscious world isn't allowed to participate. The computer is fast and it's really scientific. With AutoCAD you need to say line from here to here with a specific dimension. You're not allowing your subconscious mind to be part of the internal discussion of the project.

TS: It's too effective also. This is not a new problem. The students are able to make things look good even when in reality they wouldn't look good. That's

not a new problem. The kids who could draw could do a flashy drawing that would look good, but it reality it would have been quite different. Their facility at drawing was hurting the design. You can make bad things look good, and the computer can do that even better, and faster.

PERSPECTIVE

SF : On the topic of perspective drawing, has it influenced the way you approach architectural design? When you design a building, do you think about it in perspective first?

TS: I do.

SF: When you take students to a site, or you're drawing by yourself, you're drawing in perspective, which is a more painterly approach. It's investigative in different ways than, for example, orthographic projection, including plan, section and elevation -- the more conventional architectural drawings. I wonder if this influences the way you think about the importance of drafting, which you said earlier wasn't that important anymore.

TS: I do. I think all the good designers visualize their spaces in three dimensions. Frank Lloyd Wright spoke about this. If he got hung up on a design, he would throw it away, go sit in a lounge chair, and close his eyes and redesign it, walk through it in three dimensions, and when he had it in his mind, he'd go back to the table and draft it. I've tried it, and I think I do better design work sitting on the sofa than I do drafting on the paper. I do think you need to be able to see it in your mind's eye before you can draw anything. If it's a predominantly pragmatic issue, like a surgical suite, you're going to be able to work it out on the drafting board, but if it's primarily an experiential design, then this all comes into play.

TS: Isn't it time for a scotch?

ES: It might be.

TS: Make sure that gets into the book.

SUBJECT MATTER

ES: We were wondering if there were any messages in the fine art pieces.

TS: I like to draw, but I've always had difficulties coming up with the subject matter that's sufficiently interesting to document. What to draw? That is the problem. It's a struggle. I've tried to find some theme or subject that's interesting. There are some things I'm automatically interested in, surfaces and contrasts – both thematic and visual contrasts. In the fine arts series, the subject matter is relatively simple. There were natural aspects I was interested in, and manmade aspects that were interesting to me. The ficus tree -- who wouldn't be interested in that? It is endlessly visually interesting. So I threw that up against the Prado entrance. It doesn't exist there. The actual ficus tree is a composite of about four ficus trees that grow in Merry Christmas Park in the Grove. I took typological aspects of those trees and tied them into one. So, that whole series basically was just a play of natural things and manmade things that to me were interesting.

The fire station drawing is of the coral rock and the ferns that grow in it. The rock is a natural thing that's been man manipulated. The water tower is pretty obvious. It's the field of grass up against the water tower. It has little insects on the top. It begins to talk about the interaction between the two. That's the point where the two begin to play against one another, so the story gets a little more complicated. There's the direct effect of an intervention where the field got scraped away and the stone got thrown up against the field. The chain link fence ('Everyday Life/Granada Entrance') changes things a bit doesn't it? The fence theoretically is in that series, but I think it's more about other contrasts than it is about the natural and the man made.

ES: I think it brings into the equation the components of urban life -- the paper, the trash -- but you manage to beautify it.

TS: Well in the end it falls out of the series for that reason. It's the pretentious versus the everyday. That probably comes out because of the place. It's a gate. To the other side there was a grocery store. There are ordinary little houses with chain link fences around them. That's not so much a natural and man-made subject, but more mundane and day-to-day opposed to the pretentious and grandiose. If anything, what I'm thinking about is finding a way to elevate the mundane. The fence is a homage to the grocery store. The bag was simply there because I wanted to try to draw it. It's a little bit like 17th century Dutch painting. It's just a bowl of fruit, or somebody sweeping out the front door. I don't know if it's the affection I have for the day-to-day or the disaffection I have for the heroic.

ES: In that sense your work can be compared to Caravaggio's.

TS: Yes, perhaps, because he was poor. He wasn't nobility and wasn't treated particularly well by the rest of the world. But, it's mostly 17th century Dutch art.

SF: We wanted to ask you about the titles of the drawings. The city hall painting has a very unexpected title: June 6, 1928.

TS: The painting refers to the morning that George Merrick was fired from the commission. The box in the breezeway is all of his stuff that he took out of his office. He went early in the morning to clear out his things so he wouldn't have to deal with anybody. That narrative is a game I play. It makes it fun. The building wasn't even there when he left.

ES: The part of the painting that's missing is the melancholy. The feeling that one could imagine Merrick must have had, even though it's a one-point perspective.

TS: That's true. It's not a sad drawing. Or is it?

SF: Those elements in the drawing make it a bit melancholic.

ES: It's true. They are. What I think is really fascinating is that you're placing emphasis on the observer. It seems that the observer is a really important part of your work; how one feels when he/she sees the work. It's not always a rule for every draftsman, or painter. In your case, the emotion one would feel knowing the story behind the drawing is quite extraordinary.

TS: In the end, that probably was all about a search for another compositional element. The drawing needed another move.

SF: Did that come to you later, or was that the impetus?

TS: I always knew I needed another move, another ingredient, which, is part of the problem with all of these drawings. To complete the composition, I need a certain number of parts. It's like an interesting meal. In the case of the Merrick house (Family Portrait) it has an old chair in it because it gives it a sense of time. Part of my research in this series is to go to the Historical Society and look at old photographs. The fascinating thing about the Merrick house is that it changed so much over time. It was added on to, part of it collapsed, it was a boarding house at some point, and then it became a house museum. If you look at the photographs, the house has changed. The window locations changed when it was a boarding house. I also drew it un-air-conditioned. If you notice, all of the windows are open with screens on them. In a way, I tried to make the drawing talk about the whole life of the building, not just what it is now. Part of what I'm doing to the drawings is trying to compress time. None of these drawings is what you'll find if you go there now. In that particular drawing, I also tried to incorporate weather. It's summertime, there's a southeast breeze, and the curtains are blowing. In the City Hall drawing (June 6, 1928) I waited for an early winter morning. It's a winter sky. The sun reflects that, oddly enough. Nobody would ever know it.

The Venetian pool drawing ("Tuesday Morning") isn't really about the weath-

er. It's all about the dead palm frond, which, nobody really likes as much as they should. That palm frond is one of the coolest things I've ever done, and I really worked hard on it, and for a long time. That was the main focus of that drawing. It was part of the raked trash pile. It's another example of the anti-heroic aspects of Coral Gables. It started out as a giant trash pile and boiled down to one palm frond.

SF: You mentioned earlier that one of the most important elements of any composition is where you're sitting while you're drawing. It seems like you're often a little lower than expected. It may make the perspective more dramatic, but it also tends to eliminate the ground plane.

TS: It's all on purpose. There are two reasons. The first is that I'm not all that fond of ground planes. They're not that interesting to me. I had Douglas Duany on a jury for student drawings and he complained about it. I think it comes from a little bit of a prejudice for the still life. I like the idea of arranging these things on a plate, and the plate's not that important. The second reason is what you said. I think the world just looks a little better from a lower vantage point. In the Rome drawings it's fairly obvious. The ground plane is a mess. It's covered with bicycles and carts. It's not what you go to Rome to see. It probably became engrained in me back then. I didn't want to deal with all of that. I just wanted to deal with (Pietro da) Cortona. All that stuff is just a distraction between Cortona and me. I'm not that good at it anyway. Piranesi was the opposite. The ground plane was part of his story. All of the carriages, the trash, they were part of his story.

SF: Although curiously with Piranesi, at the time when he would have known it, the ground level in many parts of Rome was much higher than it is now. Now, through restorations, it's been brought down to its original height.

TS: I think his point was, "What's wrong with us? Look how great we once were." He even draws his scale figures too little. He draws his people at half size intentionally because Rome once was so grand; in his time the forum was

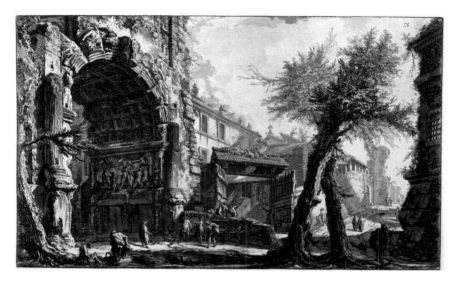

Veduta dell' Arco di Tito, circa 1760, Piranesi

a pasture. In that respect, I identify with his work because it was about those juxtapositions. He's putting unlikely things together: A gnarly tree against a triumphal arch. He's playing many of the same games I try to play.

ES: In the series with the "Landscape Workers," "Roofers," and "Builders," could you tell us what the intension is?

TS: It all starts with the intention to tell a story with the drawing. I did a thumbnail sketch with the students and I came up with that composition. Five years later I was looking through my drawings and I came across the sketch and so I went back to the site and thought, o.k. there are some other games I can play here. The golf course was already in the background, the cracked sidewalk pushing up, but I thought again, I need another move. So, I came up with the ladder. As for the yard workers, again, when I drive around, I try to find the day-to-day to include as a part of the story. So the yard workers become part of the natural. At one point there was a truck in there, but then it was boiled down and removed. (Andrew) Wyeth talks about that. He has said,

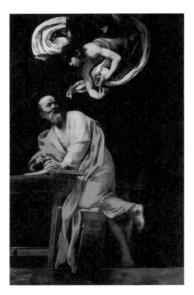

San Matteo e l'angelo, 1602, Caravaggio

"What's really hard is what to leave out." He tries to boil his work down much more than even me. The one thing I want you to really notice in that drawing is that the ladder is tilted. That's a deliberate homage to Caravaggio. It's from Caravaggio's "Saint Matthew and the Angel." You'll notice in this painting he has his knee on a stool that's tipped up and one leg is falling off a ledge. He introduces very subtle anomalies: a rotten piece of fruit, a broken violin string. It took me a long time to notice. It is the most complicated composition I've ever seen. He has three moves, and they're all on the left side of the painting. The stool is dynamic because it's in the process of failing. I don't think I got there in mine, but I got so excited about it. I thought, I'll have the Caravaggio stool in my drawing.

SF: We've spoken of Caravaggio, Wyeth, Piranesi, Vermeer and the 17th century Dutch painters. Are there other influences you've had that you would like to mention?

TS: When it comes to watercolorists, I like to look at (Winslow) Homer and (John Singer) Sargent. It helps me with teaching.

SCHOOL OF MIAMI

ES: Vincent Scully referred to the collection of drawings and projects published in "Between Two Towers" as the creation of the "School of Miami." Do you agree that there is, or there was a "school" there, and were you influenced by the work of your colleagues?

TS: I don't think the drawing history at the school has a lot to do with me. It really has more to do with Teofilo (Victoria) and the Trelles brothers and Rocco (Ceo) than it does with me. If you look at the "Between Two Towers" book, it's predominantly their work. I think I am a minor player in that story. Drawing has always been important to me. It's influenced the way I've taught freshmen in drawing classes and studios. I've always tried to teach students three-dimensional drawing as a way to influence their designs. In upper-level studios, I've said, the focus of the studio is the impact of the sketch on the design process. But, what Scully found there was not me. It was that other group. They used drawing in a different way than I had.

ES: But it seems that many of the things we talked about, from ways of understanding the world to ways of revealing aspects that are not only architectural and cultural, but also ecological and geographical, are a part of your work and research as well. Even though your work is very different visually, it is similar in many ways to the work of Teofilo, and the Trelles brothers in intension.

TS: It is, but they take a much more abstract and intellectual spin on it than I do. I do think what we share the most is close inspection. We look closely at things, but what we derive from it is a different set of things. I think we do it for different reasons. I think theirs is more interesting than mine. They're able to make leaps that I'm not able to make, and I didn't really interact with them all that much when this was going on. We didn't sit on each other's juries. I was always quite curious and fascinated by those beautiful illustrations of bugs and shirts. All that stuff that was in "Between Two Towers" I find

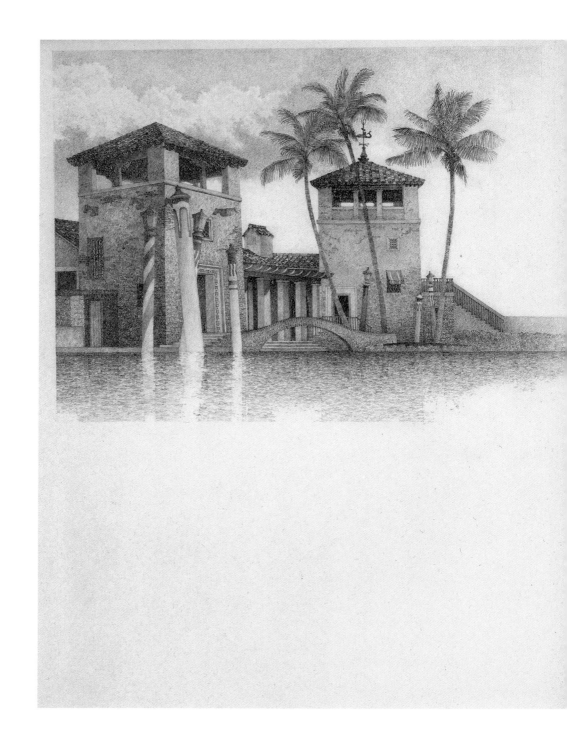

A Conversation with Tom Spain, Steven Fett and Edgar Sarli

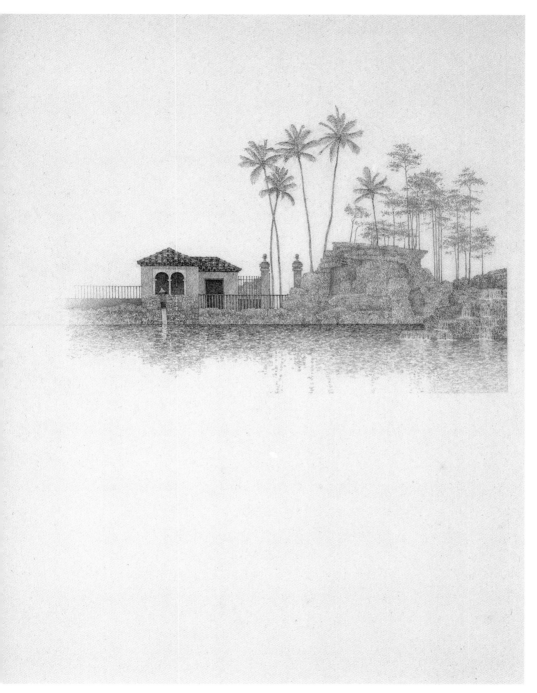

fascinating. Their work is more representational than it is literal. They're able to make intellectual leaps from that. I appreciate their work a lot.

SF: I think the devotion to drawing and the way that one composes is where there is an absolute meeting point between the two.

TS: It absolutely is. Scully was able to make that point. He could do anything with words.

CURRENT PROJECTS

ES: Can you talk about your latest work?

TS: There are lots of interesting things about Miami. I could be drawing in the everglades, I could be drawing in the mangroves, I could go to South Beach and draw, but for some reason I like the idea of limiting myself geographically and dragging the poetry out of that limited landscape. So I've limited myself to Coral Gables, and in this last series, I limited myself to Coral Way. I'll go walk, or ride up and down on Coral Way trying to find the poetic moment, and those four drawings were the poetic moments I found on Coral Way. As I've said, I need another layer for the composition, and the worker narrative just sort of came out of nowhere.

ES: Finding subject matter is another challenge right?

TS: I think so. Also, I think it's kind of overwhelming to go out and find another drawing. It's easier to find something poetic with my Vermeer-like metabolism. It's a slow moving, patient metabolism. I can cope better with just Coral Way. The rest is for me, frankly, overwhelming. It's too much.

SF: In some of your previous fine art pieces you juxtapose between the natural and the manmade landscape as well as the everyday life and the monumen-

tality of Coral Gables. These recent drawings continue this exploration, but add more ephemeral subject matter. They include change as it is happening. A lot of work is being done, a lot of improvements are being made, and you're sort of celebrating and capturing that moment in time.

TS: The consciously constructed reality of Coral Gables includes all these social symbols, like the tall rock walls, the gates and the monuments. It's what people tend to think of when they think of Coral Gables. Then there is the evidence of the mundane life. A more invisible life. The guys mowing the lawn, the trash piles, the hole they are digging in the street. So, the juxtaposition that I have worked with up until this latest series of drawings has been generally about that contrast. It's the everyday versus the monumental. Monumental in its functional sense, not necessarily its physical sense. We build monuments to what we think life is. The fronts and backs series is the best example of that. When my kids were small, I would walk them around the neighborhoods. We lived in Coconut Grove, and I would often walk them through the South Gables. Through observation, I realized that front windows in most houses are complete fabrications. At night or at dusk you see that rooms beyond have been composed like a painting to be seen from the outside. It's rare that anyone lives in those rooms. They are constructed versions of what life is supposed to be. The backyard is where life really happens, and is therefore much more interesting, and more poetic to me.

ES: I think the drawings are made more powerful when you imply certain things instead of drawing them. That's where the work is most intriguing. Every time we've visited you, we just dive into the work because you're not telling us exactly what's there. You're suggesting something we have to discover, it takes time to know what you are really trying to say. That's what brings the work closer to me. You're letting me be part of it.

TS: There are very, very few people who will. I watch their faces and their eyes. You have to look, and you have to go in and look again, and then I know you're actually consuming the drawing.

TECHNIQUE

ES: How long was the process to complete the builder's series?

TS: It took me about four years. That's a year a piece. It's what everybody asks. The time it takes, from going out, looking for the idea, collecting all the historic photographs, and doing the composition studies, is about a year. I want to collapse it to six months. I also went from a 2H pencil to a 4B pencil, thinking that would speed me up.

SF: That's a big leap.

TS: It is. I went to the 4B thinking that I wouldn't be able to show as much detail, which nobody sees anyway. It turns out if you sharpen it enough, you can get the detail out of a 6B, and it's only a little darker.

SF: Some of the Rome drawings, I'm thinking of San Agnese, Piazza Navona, and Sant'Ivo. Those are very hard pencils aren't they?

TS: They are 2H pencils.

ES: Do you use just one type of lead per drawing?

TS: I don't like to mix them. What happens is that you get different textures. If you've ever worked with a harder pencil and then have gone over it with a softer pencil, nasty things happen.

ES: So you keep to 2H?

TS: Well, 2H, H, F, a lot of it has to do with the weather and humidity. I keep trying to make it less work-like. The softer the pencil, the less detail you can put in and the easier it becomes. You don't have to work so hard at it. The black and white pastels have a blunt edge. When I use them I know I can't

draw a lot of detail, so I have to chase another story. It's so liberating. I just sit there and make a mess. When I'm using a sharp pencil, I see everything, so I feel like I have to draw it.

ES: Would you say that combining pastels and pencils is a crime?

TS: I think anything is o.k., as long as it works and as long as you're enjoying it. A 6B pencil is very much like a pastel. It's so soft. I guess sometimes I'll mix them. In the Coral Gables series, I'll go from a 2B to a 6B because with the 4B and 5B you get really black. With a B or an HB you just get gray. I'm trying to get more contrast.

SF and ES: Tom, thank you for spending the time with us. We enjoyed it so much, and we hope this interview will be as helpful to those who read it as it has been to us. We feel that your work has significance and meaning, and even though your humility won't allow you to admit it, it's also poetic and intellectual. It's informed by the greatest of painters in history and yet is truly individual, revealing a delicate balance between compositional dynamism and technical prowess. We understand it more profoundly now and hope that this interview will have the same effect on those who read it.

A Conversation with Tom Spain, Steven Fett and Edgar Sarli

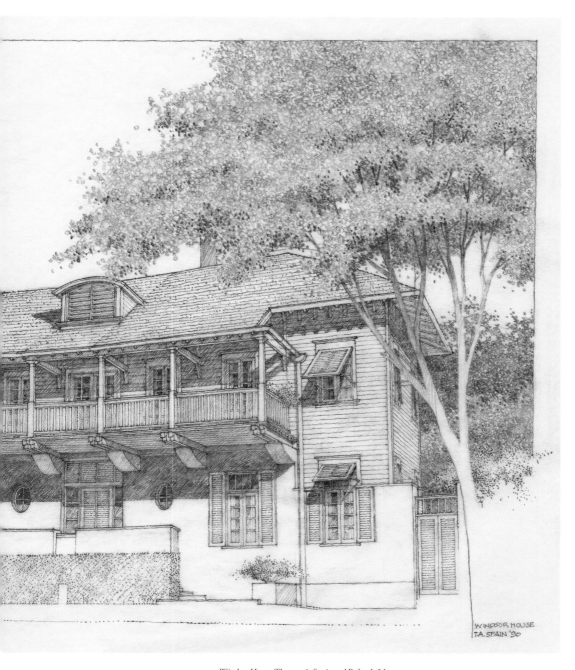

Windsor House, Thomas A. Spain and Rolando Llanes, 1990
Pencil

Transcribed Lecture

By Jorge L. Hernandez
September 12, 2014

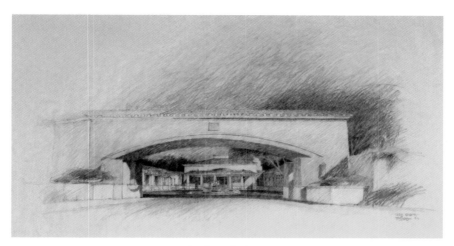

Casa Egosita Study, 1992
Colored Pencil

From transcriptions by Chloe Johnson, Camilo Tirado and Tina Zeng

It really is a pleasure to share some thoughts on the drawings of Tom Spain. Tom is an architect, an artist and a teacher. He has intertwined these three aspects of his persona into a pillar, which has supported an incredible outpouring of creative work since 1966. He received his Bachelors of Architecture from North Carolina State, a Masters in Arts from the University of Miami, and a Masters in Design Studies from Harvard. He probably would have drawn in exactly the same way in spite of all that education, because his drawings connect to the world around us and he has a unique way of seeing and presenting that world to us.

There are a couple things that I want to note before we get to discussing his work, and that is Tom's involvement here at the School as a teacher. Because of his long tenure here, there are generations of alumni who can

count him as their professor. I am fortunate to be one. He always was very thoughtful in constructing his academic assignments regardless of our particular skills at any given moment. He fashioned exercises to place us at an intersection of mindful crafting. The point was to get us to really understand, know and think about place. I remember an assignment in which he had us read the libretto and listen to the opera Porgy and Bess, then hear Miles Davis' rendition, then have us look at the original stage set and design a new set as if Davis was going to perform in a stage of our making. Of course, discussions of Charleston and "the fictitious" Catfish Row were not absent from the classroom. The point of the exercise was this notion inherit in Tom's work. It is the idea that art begets art begets art begets art. Like any good artist, he is very well schooled in the history of his tradition -- particularly in a kind of personal, analytical way with those who have influenced him and his craft.

The intention of this lecture is a twofold: one, to talk about certain compositional delights and discoveries that I've found either by my own observations or by long conversations with Tom about what he does. And two, to talk about the tone and message of his work. I think when we consider these two qualities together there is a kind of synergy or unity that talks about Tom Spain, the person.

As many of you know, Tom has had a brilliant career as an architectural renderer, an artist and a practicing architect. He had an enormous influence in the built environment by collaborating anonymously with the architects who hired him as a renderer. His was a steady hand to hold on to, while giving shape, life and flesh to an architectural idea. In the process of rendering, he was a phenomenal editor. I have had the benefit of working with him in this capacity multiple times. When he did the renderings for the Coral Gables Museum, I know for a fact, he helped greatly to give the community the confidence to move forward with the Fewell Gallery, even though it was not originally included in the scope of the buildings program or the budget. So, for all of those who have benefited from your company in that regard, Tom,

Fewell Gallery, Coral Gables Museum, 2010, by Thomas A. Spain and Jose Miguel Silva

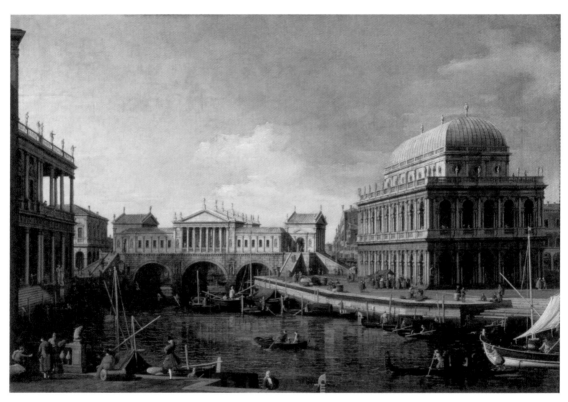

Capriccio con Edifici Palladiani, circa 1756, Canaletto

I thank you. It's hard to think of a project in town that did not include Tom's voice -- quietly, outside the limelight.

My favorite of his works, bar none, is a house that he restored for himself and shared with Dona, his wife, on Santa Maria Street. The house was originally designed by the architect Robert Law Weed. It's a wonderful house because, with Tom's interjections, it is full of surprises and unexpected scale changes. At the same time, it's very truthful to Weed's original voice. As you approach, for example, recessed within a niche, a stone frog perched sideways in an Egyptian manner, spits water into a basin above which terracotta flowers perpetually bloom. Just before you get wet, you take a-right-and-a-left and then enter a low-slung entry into the house. My favorite part of the house is the magnificent porch that they added. It is the best porch in Coral Gables. What I don't know for sure, is if the quality of the place has mainly to do with the architecture, the convivial conversation, the single malt scotch, or the generosity of Tom and Dona's friendship. I have been fortunate to savor all of those in that space, and I'm sure many of you have as well.

So let's get to the drawings, specifically, Tom's sketches of Coral Gables and Rome. The medium is varied: pencil, colored pencils, pastels, watercolors and so on. Most of them are plein air works. Tom loves to be outside, drawing either by himself or with students. If we drive around Coral Gables, or are lucky enough to walk about in Rome, we'll often see him drawing. These drawings have a directness with the environment. Then there is another kind of drawing, crafted on his drawing table at home. These are fine art pieces, but we can also call them capriccios, following a tradition in painting and architecture.

Here we see an example of a capriccio by Canaletto, which is a tribute to Palladio because the Rialto Bridge in the center of the canvas is not the one that was built, but rather Palladio's competition submission. On the right is the basilica in Vicenza and on the left of the frame, only marginally visible by its silhouette, is the corner of Palazzo Chiericati, also in Vicenza. Canaletto paints for us here

a Venice that never was; a Venice of the mind, of Palladio's mind. He makes us think about this relationship of capital city to territory because most of the buildings in the frame were never built in Venice.

About Tom's Capriccios, there are 12 works in all. I will discuss some of these and fold other works into this talk. We begin with what is now the Coral Gables Museum, which used to be known as the old police and fire station. Tom's title for the drawing is "Fern/Old Police and Fire Station". It's a very interesting drawing. I first saw it while collaborating with Vincent Scully on "Between Two Towers," I thought it was an abstraction, like a collage, because of the planar quality of the piece, and the way that the forms partition the picture plane. I came to find out, years later, while working on the restoration of the building that it is an accurate depiction of the structure from across the street. This ambiguity is a quality unique in Tom's work. I don't know how many of you saw the article in the Miami Herald announcing this exhibition, but it referred to the drawings as etchings. Tom's oeuvre does not include printmaking but, if you look carefully, the surface is treated like an engraved plate. This attention to surface detail raises the level of artistry to that of a virtuoso. At Tom's previous show in the Coral Gables Museum, he hung "Fern/Old Police and Fire Station" low on the wall immediately after the entry. Because museum-goers realized that the work depicts the building they were in, everyone bent down to look at it. It was quite wonderful that the drawing was hung low, on what was once an exterior wall made of oolitic limestone. People were looking at the rendition of coral stone in the drawing and comparing it to the coral stone of the wall. This caused major gridlock into the gallery, an effective trick. Parents would get their kids and say, "Look! Look here!" and "Look there!" They would point back and forth from the actual coral stone wall to the drawing, alternating between the real and its representation. He pulled them in by this strategic placement of the piece, but more importantly, by his masterful representation of textural surface.

Jorge L. Hernandez

123

Column base, print from copper plate etching Giovanni Battista Piranesi (1720-1778)

No 12 Yellow Orange-Red on Orange, 1954
Mark Rothko

There's this love of surface, which we'll see time and again in his work, and the handling of surface, so crafted that the drawings are often confused with etchings. They are not etchings. They are drawings. He labors over them ad infinitum under a lamp on his desk. (Giambattista) Piranesi loved to work the texture of the surface. This is an unusual Piranesi etching. It's not a veduta, or view, which would be more common. It simply is a block of stone on top of which stood an important column, now missing. Authors conjecture and speculate on the lost column because Piranesi simply rendered the block. It has a flat frontal quality and it pulls you in by the rendition of texture, just like the drawing of "Fern/ Old Police and Fire Station."

On Tom's supposed flat surface, you start to see the kind of atmosphere that Piranesi produces in the rest of his works. There's this notion of surface as atmosphere that can be read simultaneously flatly and as deep space. In Tom's work there is this phenomenon of contrasting surfaces, atmosphere and depth.

Similarly, the great abstract expressionist, Mark Rothko, would paint layer over layer over layer of color. The result is like a veil. He pulls you in and you put your nose two, three, four, or five inches away. You can look through the color at the color beyond and sense the mystery behind these veils. I hope you see the similarity between Rothko's color veils and Tom's rendered surfaces. There is always this notion of physical engagement in the work.

The flat collage-like quality of "Fern/Old Police and Fire Station," which is in fact a perspective, pulls you in. The other method is the compositional use of the sky. Sky is very carefully crafted in Tom's works. It's either given an extraordinarily large and overly generous section of the picture plane or it's limited to just a sliver, as here, like a Chinese scroll. The eye rises across these layers of coral walls up to a sky.

Tom's drawing of the "Campo di Fiori" in Rome is about the volume and shape of the sky. Sky is the protagonist. There is barely a sense of any buildings there, just ghostly images, faint and distant. Are they dreams or a mirage? Is this a real place or a place remembered? Two buildings almost touch. They are pinching that space of sky as if it were some supple piece of flesh you can squeeze and roll your fingers on. The sky has volume and a tactile quality, that relates very much to the descriptions of early settlers here in South Florida who called it "the dome of the sky." The clouds in southern Florida are a silhouette of an absent mountain range. They model the sky, becoming ever present in our consciousness.

One of Rome's most wonderful places is the Campidoglio by Michelangelo. In classical architecture, just as in archeology, you can pretty much build the body of the building from a noble piece of it, from a fragment, because of the reciprocity of part-to-whole that happens in Classicism. It's the DNA in the fragment that generates the entire work. It is what Vitruvius calls "eurythmia and symmetria." With a fragment you can assemble the entire piece. Tom shows us just a corner of the Palazzo Senatorio, a small portion of its fountain and the space beyond. You immediately recognize the entire place.

Sky, fragments, surface, and atmosphere are Tom's way of seeing our world. His drawings of Rome and Coral Gables are really for those who know Rome and Coral Gables. Of course, everybody can appreciate them, right? But for those who are well versed in these places, we take exceptional delight in figuring out where he positions himself, where he sat, and how long he took to compose the frame in which to draw the picture.

The next group of capricci convey a social and ethical dimension. These drawings develop a narrative. They are pictures as a vehicle for a morality tale. "Everyday Life/Granada" (Figure on pages 60-61) is particularly poignant for me because I came to the U.S. when I was five years old -- a first generation immigrant. My parents, like the parents of many, labored intently, yet we could

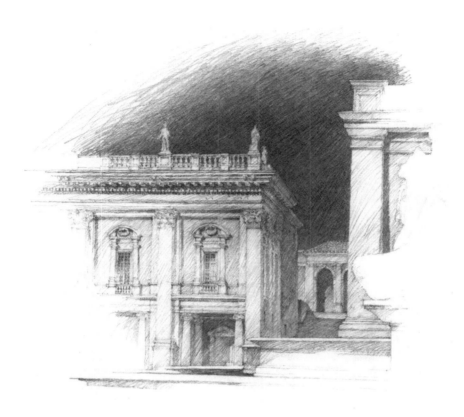

Piazza del Campidoglio, 1991
Pencil

Campo de Fiori, 2006
Pencil

Jorge L. Hernandez

127

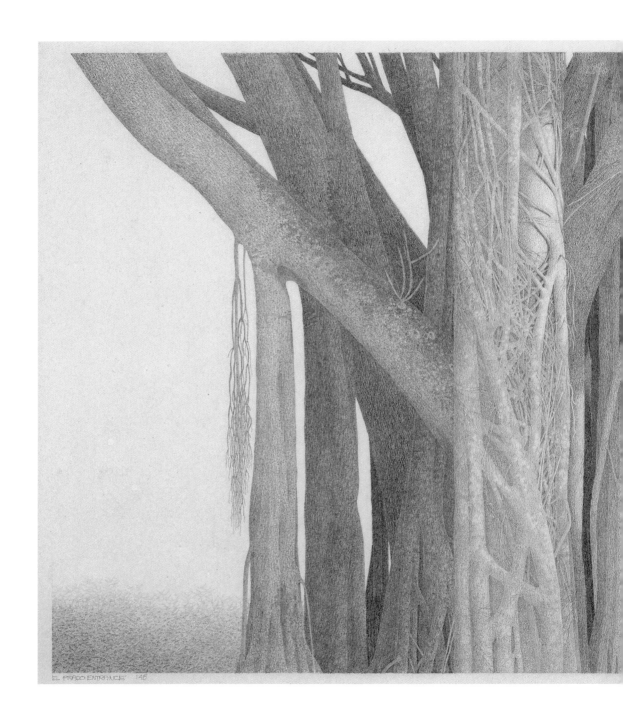

EL PRADO ENTRANCE 146

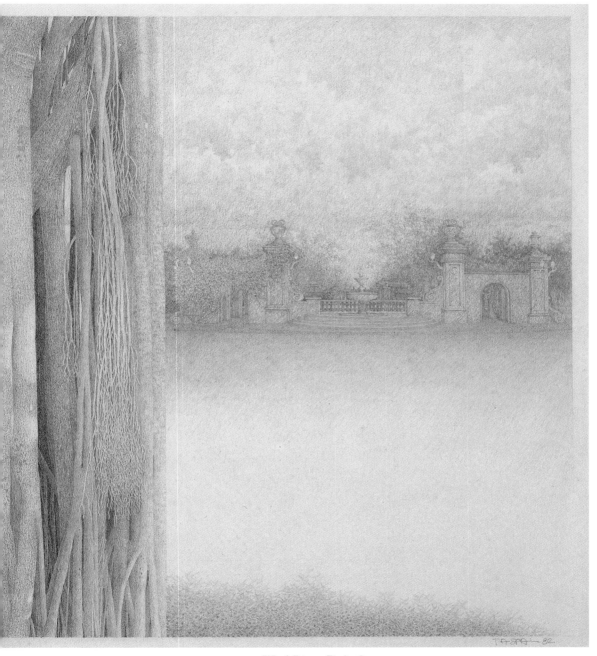

El Prado Entrance (Ficus), 1982
Colored Pencil

Jorge L. Hernandez

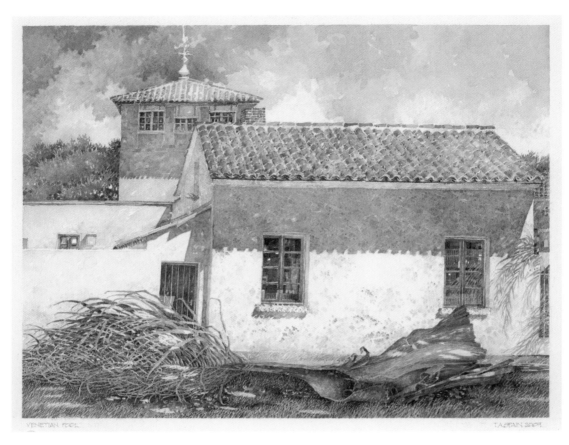

Tuesday Morning, 2009
Watercolor

not have lived anywhere near this place, Coral Gables. Our Sunday drives would take us through the arch and into this place we so cherished for its beauty but could not afford. At the time, I believed that the houses of Coral Gables were real Spanish colonial buildings. So Merrick's conceit worked. In this capriccio, Tom speaks to the notion of social strata in quite a factual way, without much angst. It has an element of upstairs downstairs commentary. The masterfully rendered crinkled and discarded paper in the foreground is trash, and when juxtaposed to the great gateway, represents the aspirational and quotidian aspects of life. Both are important in architecture, and in city making. There is the glorious entrance and my reality outside the archway comprised of the dusty street, the crumbled paper and the chain-link fence.

"El Prado Entrance/Ficus" (Figure on pages 128-129) recalls Vincent Scully's "The Natural and the Manmade," a theme that Vince Scully would often use. Tom's drawing prompts us to reflect on the necessary reciprocity of making and keeping. The strangler fig in the foreground is masterfully rendered, clear and precise. In the background, faint images of the manmade world beg us to revisit the eternal question of balance and rightful order. The drawing speaks to necessity of an architecture of purpose and to the relationship between architecture and nature, and it does so very beautifully.

"Tuesday Morning" is related. Here, color is back. It's a tropical sky. Yet, there is a disproportionate allotment of flat space in the drawing, taken up by a modest building. The building shown is nearly an elevation. Its textures are beautifully rendered. They carry the eye upwards to a small section of great dome of the sky. Tuesday is the day that trash is collected in Coral Gables. There is a dried palm frond on the ground and yard clipping refuse in a trash pile. This elegantly rendered façade is the back of a building. It's the back of the Venetian Pool, the great spring fed swimming hole of the City, yet the small pavilion is drawn so beautifully that there is no desire to come around to the front face of this place. Here, the backstage drama of quotidian life plays out in full tropical color.

In this work, Tom is subjecting a perspectival view to the rules of orthographic projection, as a way of including deep and flat space within the picture plane. Both perspective and orthographic projections are interdependent means of composing architectural space. He mixes the two very skillfully. They are tools he has used all his life as a teacher and an architect. These perspectives are intended, first and foremost, for architects because of this very explicit use of both orthography and perspective simultaneously.

The general feel of this work evokes Winslow Homer's portfolio of the watercolors of the Caribbean. The pink wall of Tom's pavilion is replaced by the white wall of Homer's Caribbean seascapes, a white wall which, at times, becomes foreground, middle ground or background. In Homer's watercolors, the better portion of the white page is left unpainted, but not devoid of the artist's adroit skill. The unpainted void is the principle figure organizing space.

We see a similar technique in Tom's drawing of the Dutch South African Village in Coral Gables. I think these drawings are composed on the page either instinctively or carefully to balance the white and painted portions of the image. The unpainted white is the principal part of the image.

In Rome, this becomes even more evident. Here Tom is singing the refrain of no ground plane. In "Sant'Ivo," (Figure on page 38) the wall of the courtyard is ever present yet barely drawn. The void supports the spiraling dome in the white sky. A number of students who are present tonight have drawn with Tom in Rome. They often cite what he repeatedly tells them, "Don't draw everything, it's more powerful if the mind completes it." This is yet another way that the observer becomes an active participant in the work of Tom Spain. His drawings are always absent of figures but never absent of the human presence. He pulls us in.

The unfinished piece has a long trajectory in the history of art. There are

A Garden in Nassau, 1885, Winslow Homer

Shore at Bermuda, circa 1899, Winslow Homer

Dutch South African Village, 2009
Watercolor

Jorge L. Hernandez

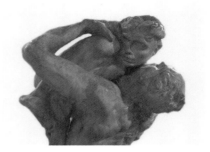

Je suis Belle, circa 1881, Rodin

Atlas Slave, circa 1525, Michelangelo

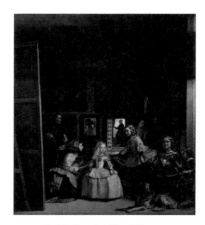

Las Meninas, 1656, Diego Velazquez

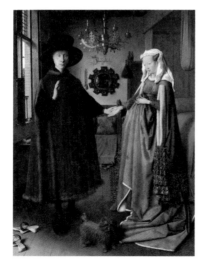

The Arnolfini Portrait, 1434, Jan Van Eyck

the slaves of Michelangelo, the many works of Rodin and the drawings of Da Vinci. The incomplete nature of these works engages us in a psychological dimension. In the marriage portrait by Van Eyck, he pulls us in to the scene by the reflection in the mirror. The audience of the nuptials is the center of the view. Likewise, Velasquez's, "Las Meninas," positions us in the place of the Royal couple. The members of the Royal family and the artist are before us while the image as king and queen is reflected in the middle of the painting in a mirror. The entire picture becomes a conceit. Who is painting who? A large portion of the composition is assigned to the back of the canvas. This indicates a fascination with the inner workings of a place, like an alley way in a city.

Turner desired to paint ephemera. Oscar Wild said, "there was no fog in London until Turner painted it." The whole world is reduced to light, steam and vapors, you can barely sense the world at all. In Tom's study of the "Prado Entrance" (Figure on pages 128-129), the world is reduced to ephemera where the precision of the piers, the pilaster and the pergola matter less than capturing the mood and the atmosphere.

Rain, Steam and Speed, 1844, J.M.W. Turner

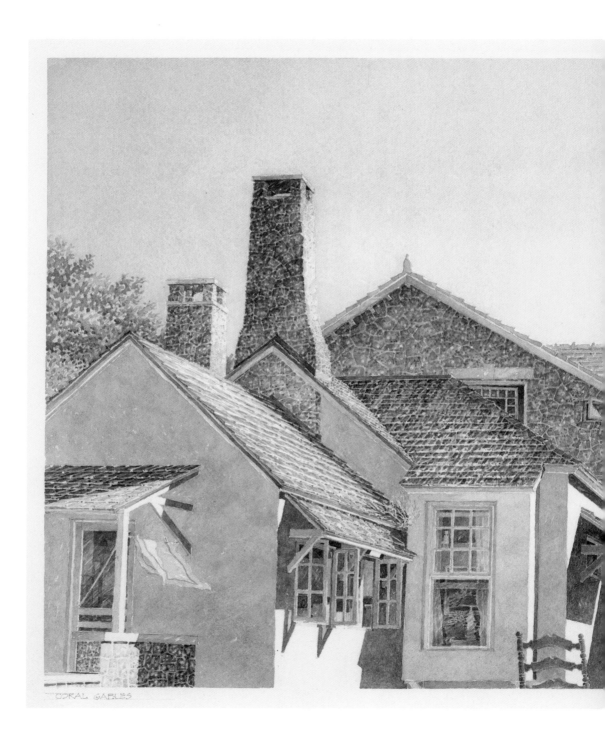

CORAL GABLES

Transcribed Lecture

Study sketches of the Merrick House, 2010
Pencil

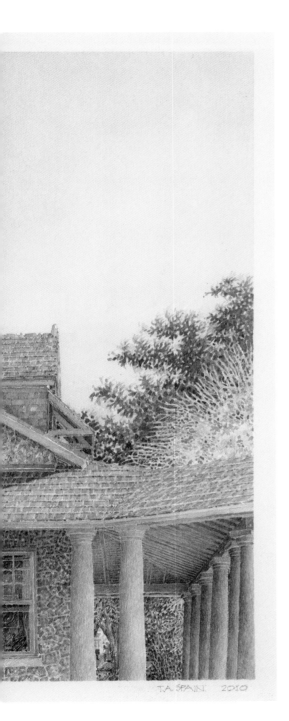

T.A. SPAIN 2010

Family Portrait, 2010
Watercolor

Jorge L. Hernandez

137

"Family Portrait" (Figure on pages 136-137) recalls the story of the Merricks who came here seeking tropical warmth after a family member was taken by a New England winter. They bought this plantation, sight unseen, and called it Guavonia. They moved into some ramshackle shacks, started a school for whites and people of color, together. Merrick's mother eventually designed and built the house we recognize today as the Merrick House, the foundational structure of the City of Coral Gables. Tom's portrait of the house is seen from the back. Absent in the view is the great coral stone gable from which the City takes its name. What we see is a bit of the old shack, which was never completely dismantled, annexed by Mrs. Merrick to the grand house. We see tiles on the porch, towels hanging on clothes lines and the open windows. We see windows that are no longer there. This is not a snap shot of the house at one particular time. Rather, it is a compilation of the elements of the house over time. This is the story of a house as a combined portrait, with all the physical changes made in time by the people living there, facing hard times, building additions, and slowly changing the architecture. It is a psychological portrait of the Merrick family seen through the lens of changes made to the family house over time. Here again, Tom juxtaposes an orthographic flat façade with the exaggerated perspective of the porch. The theme of orthography and perspective or flat and deep space repeats. The vanishing point of the one-point perspective is hidden behind some foreground element of the drawing. Tom conceals the point to which all things recede. It is a technique he repeats. I call it the "banished vanishing point." This allows him to remove the house from the ground plane. The house never engages the Earth even as tactile and accurate as the cedar shingles and the classical columns appear. The overall mood is other worldly because of its separation from the ground plane.

I'm going to show two pictures, one by da Vinci and one by Michelangelo, both monuments of the history of art. I am sure you know them. They are peculiar, arresting images. They are images that require deciphering the iconographic peculiarities to obtain their hermetic meaning. The first is a painting entitled "The Virgin and Child with St. Anne" by da Vinci. It ap-

The Virgin and Child with Saint Anne, 1508
Leonardo da Vinci

pears incredibly odd. One immediately questions the nature of what we are looking at. Is that one woman or two? Is this a Renaissance painting of time lapse photography? If you cover Mary's face, the image appears to be one woman, Saint Anne. When you study the Virgin Mary's posture on her mother's lap, it is an uncomfortable and unconventional pose. Da Vinci is blending, today we would say morphing, the two figures together. There is a mastery of color and perspective harnessed in the telling of a story. If you are Catholic, you're interested in the theology of the innovative and ambiguous piece. The painting is a visible narrative of the doctrine of the Immaculate Conception. What da Vinci paints is the human lineage of Christ, a portrait of his DNA across three generations. The artificiality of the capriccio becomes a morality tale or a life lesson.

Jorge L. Hernandez

The Holy Family, 1504, Michelangelo

The second image is the famous "Doni Tondo" or, "The Holy Family" by Michelangelo. At first glance, it appears even more peculiar than the da Vinci. The colors are almost acid, like the Sistine Ceiling. The painting is circular in an original wooden frame possibly designed by Michelangelo. The circle is divided in two zones. The top zone is a classical landscape populated by nudes, all in familiar academic poses. What are they doing in a painting of the Virgin and child? Bisecting the circle is a gray line. Could it be a "Haha" from an English garden, a threshold, the top of a wall or just a gray line painted to bisect the circular canvas? We realize that the figures behind the line in a landscape vanishing towards the horizon are representing pagan antiquity. Everything in front of the line represents the dawning of a new age. Negotiating the line is the infant John the Baptist. The painting is a timeline before the line and after the line. In the foreground is a trinity of figures: Joseph, Mary and Jesus. Some of the qualities present in the da Vinci are repeated here. Ironically, Michelangelo is the younger and da Vinci the elder, but this painting predates da Vinci's the Virgin and Saint Anne, by two years. Look carefully, where is Joseph's arm? You think this is it, but it's really Mary's left

arm. Again, the postures are almost impossible to assume. This contributes to a double reading. The male figure initially appears to be Jesus' earthly father, but in fact is the divine Father handing the savior across the gray line, the threshold of existence to his earthly mother. The painting symbolizes divine birth and holy incarnation. Again, the artist demands a decoding of the iconography to decipher the hermetic meaning of the enigmatic piece.

In Serlio's treatise on Architecture, there are illustrations of three genres of dramatic scenes: comedy, satire and tragedy. The comic scene features a picturesque village where the buildings step up and down from each other in half levels. Balconies overlook loggias which overlook other balconies and so on. One can imagine the actors emerging from these mezzanines, balconies and lofts making the entire scene quite animated and light hearted. The scene for the satire is a forest. Ironic commentary and satirical commentary would be staged here. We see shacks in the woods forming a ramshackle scene absent of the propriety of civic life. The last scene is the tragic scene, where the great tool of Renaissance one point perspective is harnessed to its maximum affect. The entirety of everything, obelisks, porticos, pediments, temples, etc. diminish towards the center of a great triumphal arch. The gravitas of the setting relies on classical architecture and Roman antiquity. You can imagine where the actor would stand – on the axis or off the axis, what he would say from each station and what that would mean. The last three of Tom's capricci, assume a comedic satirical and tragic tone.

Tragic Scene Set Design, 1545
Serlio

Comic Scene Set Design, 1545
Serlio

Satyrical Scene Set Design, 1545
Serlio

Jorge L. Hernandez

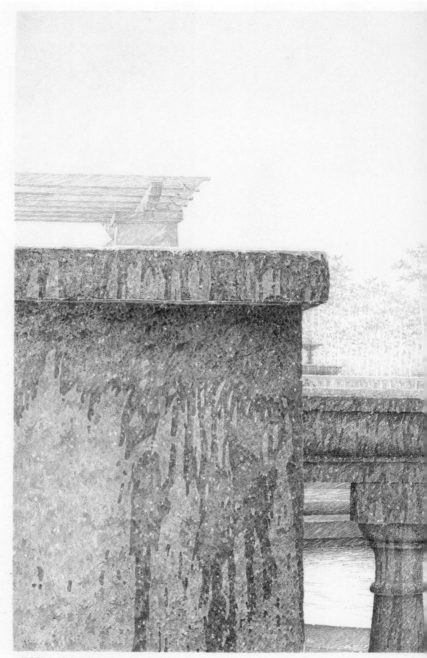

PRADO ENTRANCE

Quinceanera, 2010
Watercolor

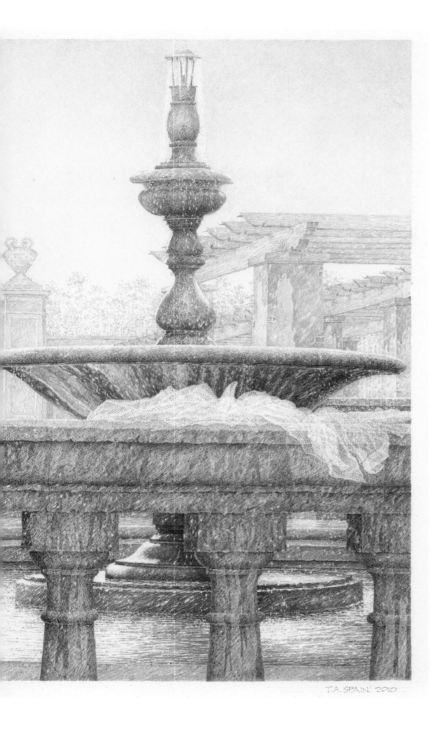

Jorge L. Hernandez

The comic scene is called "Quincenera." (Figure on pages 142-143) Everyone laughs at the title because a quincenera is a coming of age party. It is a hispanic version of a debutant. On any given sunny day in the beautiful setting of Country Club Prado in Coral Gables, the place is overpopulated with teen-aged girls in yards of lace and tulle, hoop dresses, veils and all that stuff. The photographer, mother, grandmother, cousin, aunt, make-up artist and everybody else are tend to the girl, like a 15-year-old queen with her court. So quite comically the South Florida deluge pours down and chases all the actors away. The only remnant of the human drama that remains in Tom's picture plane is a torn part of the girl's dress as she made her escape from the wash of waters. There is a technical virtuosity to the piece that aides in conveying the sense of hysteria. The quality of the surfaces and the atmosphere are drenched and dripping with water, reflecting and impregnating everything.

The second capriccio is very curious and entitled "Fink is Gone." (Figure on pages 146-147) It is an ironic view taken from a back alley of the George H. Fink studio, which is one of the true architectural jewels of downtown Coral Gables. Tom draws it from the back, an ironic twist to the great architect's prolific career. The foreground, a dumpster, is filled with drawings and files and the architect's T-square. The rise and the fall of this City, of the human condition, of human fallacy, are all implicit here. Compositionally, the piece is very interesting because it relies, again, on orthography to structure the view. The cadence marked by telephone poles and electrical wires march across the rear façade creating a modularity to the plain back of the structure. This rhythm patterns an otherwise long, flat façade. The sky forms an absolute clear shape and is relegated to the top quarter of the page. The composition of elements moves up the wall like an oriental scroll until the finials, turrets and towers typical of Fink's hand, populate the realm of the sky. The ground is nowhere.

"June 6, 1928," is the tragic scene (Figure on pages 148-149). It's the supposed day when Merrick was ousted from town. Now he is deified, but after the hurricane of 1926 and the beginning of the real estate market crash, he was not so popular. This is Tom's last version of multiple views of Coral Gables City

Hall. Here, the heroic hemicycle facing Miracle Mile, is not visible. The building is drawn from the back, turning its honorific face away from artist and viewer. The rear façade, big, planar and orthographic in this depiction, appears as a great and tragic stage set. The early morning rays of yellow light accentuate the loggia behind City Hall, drawn here as a Renaissance one-point perspective, resembling the tragic scene. The founder has been removed from his town. In the foreground is a dumpster of files and papers and things thrown away from his office. Wooden studs bracing the palm are a reference to the hurricane. There is also a little ladder drawn up at the top of the clock tower, probably used to fix the leaks the hurricane produced. It's still leaking today. These last three capricci speak of the sensibility in Tom's work. They convey a message that one approaches as you get to know Tom and his interest in social issues. They are a search for that certain kind of beauty that is not normative. They are a celebration of everyday life, an elevation of the common person, all executed with the skill of an incredible hand. The protagonist of these scenes is neither a prince nor a pope nor even a developer. In fact, the protagonist is the artist, the everyday man as artist, observing and recording our world in his way. He is both Hera and Mercury tending to flame and threshold, ensuring that the desire burning in every human soul, the desire for a thing of beauty, will not be extinguished.

There is one final drawing that is not a capriccio, but a view drawn in Rome. I will not show it to you tonight. Instead, let's try to imagine it. The lights in the hall are dim, so let's try. We can paint an image of it in our mind's eye. It's a drawing of the Colosseum (Figure on page 155). We are all Tom's students. It's Rome. It is a cold, dank and drizzly day. We have a drawing assignment. We grab pads and pencils, gloves and scarves and go out to draw the Colosseum, the great beast, a monument everyone knows. The day seems suspended in the gray of twilight. There is no color. When we finally arrive, we arrive at the center. The first thing we have to do is position ourselves relative to it because that's the first act of drawing. We ask, what is the relationship between me and it, it and me? What is the relationship between Rome and the nebulous sky? We select our point and mark our position. We begin to draw. A conversation ensues. It is a conversation between the page, the building and us. We know that it sits on a plane. The

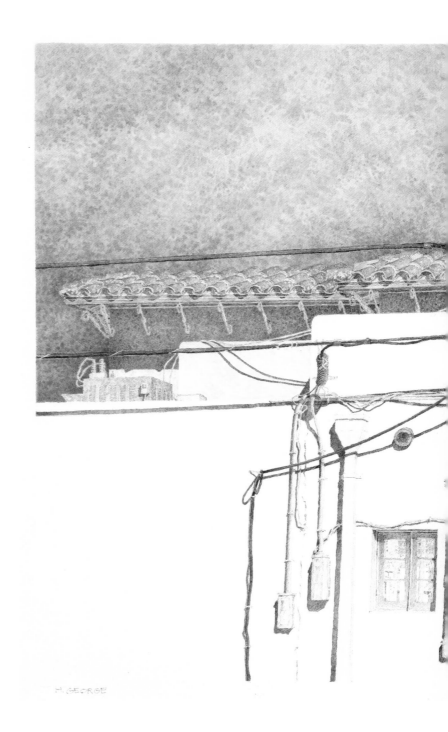

H. GEORGE

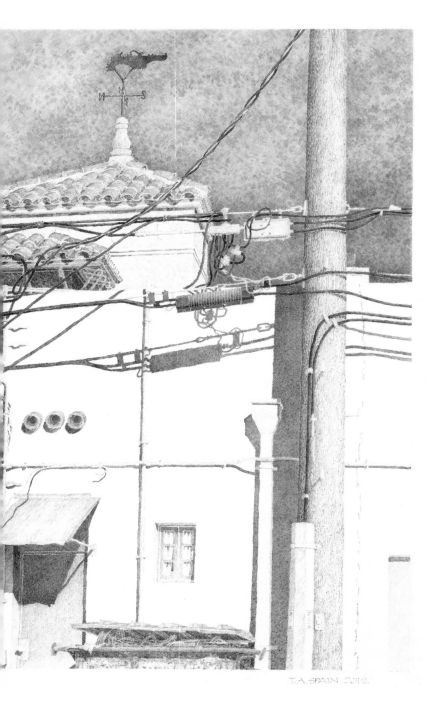

George H. Fink is Gone, 2012
Watercolor

Jorge L. Hernandez

147

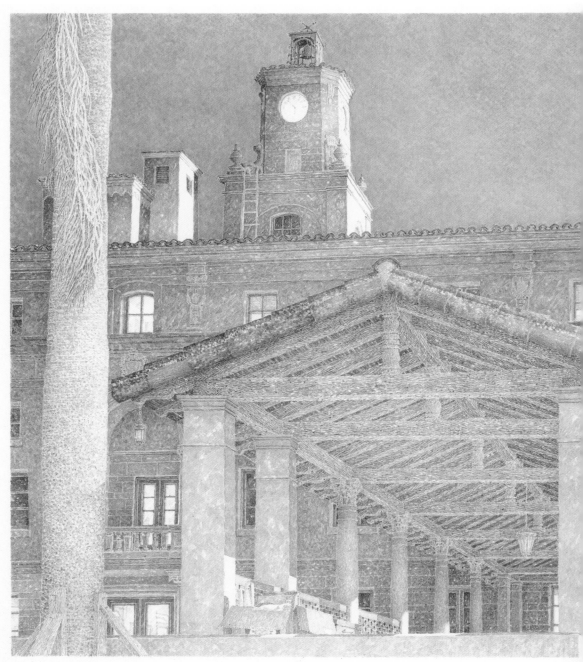

JUNE 6 1928

Transcribed Lecture

148

Drafted study of June 6, 1928
Pencil

June 6th, 1928, 2011
Watercolor

Jorge L. Hernandez

149

behemoth sits on a plane. We sit towards the top of a surrounding hill. We can almost see in through the top of the rim of ruinous brick and stone. We start to commune with it. As Vincent Scully said, "Cities are built across generations, in place across time," so we commune with it. The mood is melancholic. The light is melancholic. There is a row of cypress trees nearby, lending to the scene a funereal note tone. We start to draw and we realize the structure has been abused. The epidermis has been plucked by the vulture-like actions of popes. Perhaps it is better this way, exhibiting its most noble quality, the great curved wall of beautifully unadorned brick inside of which horrors happened, barbaric acts of man against beast, beast against beast, man against man. Talk about the rise and the fall, right? This continued until it broke open and that drama ensued in the streets of Rome. Rise and fall. And so we keep drawing. Tom helps us, but also leaves us to our thoughts before this monster. He makes a drawing too, the one I won't show you. His talks about that sense of connection with place, that is his work. It is hard for me to describe it better than to quote a stanza by Calderon de la Barca from "La Vida es Sueno." It's a famous work of the Golden Age of Spanish literature about places as dreams, about what is and is not real. Am I in the frame? Am I out of the frame? Am I acting or observing? The sort of ideas we've been discussing in relation to Tom's work all night.

"¿Qué es la vida? Un frenesí.
¿Qué es la vida? Una ilusión,
una sombra, una ficción,
y el mayor bien es pequeño;
que toda la vida es sueño,
y los sueños, sueños son."

"What is life? A frenzy.
What is life? An illusion,
a shadow, a fiction,
where the greatest of good is but small;
for all life's a dream,
and dreams are only dreams."

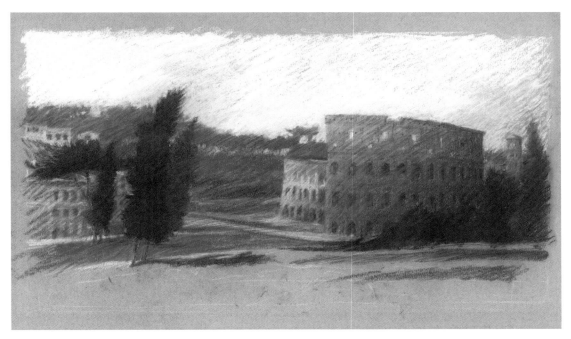

Colosseo, 1991
Black and White Pastel

Jorge L. Hernandez

About the artist

Thomas A. Spain is an architect, artist and educator based in Coral Gables, Florida. He received a degree in architecture at N.C. State University in 1966 and shortly thereafter moved to Florida when he was offered a position to teach in the architecture department (then in the School of Engineering) at the University of Miami. In his first few years in Miami, Spain balanced his teaching duties with advanced painting coursework and military service during the Vietnam war. He earned a Master of Arts in 1970. As the department grew and gained prestige, Spain took a larger role in helping to shape a newly accredited School of Architecture. He also helped to establish a successful Miami-based architectural practice with Rolando Llanes, a Miami alumnus and former student. Having earned tenure and with his children grown, Spain then attended Harvard University and earned a Master in Design Studies degree. Yet despite these academic and professional accomplishments, undoubtedly, Spain's most consequential work is his art. Drawing and painting have been a constant in his life. While teaching, Spain annually led groups of students to Rome, allowing him to slowly amass his own celebrated, and often exhibited, collection of work. His Fine Art, set in Coral Gables, is more personal, and charged with social commentary. By carefully studying the technical prowess in the art making, and the intellectual discourse implicit in the subject matter and compositions, we begin to understand the man.

Recognized architectural designs

Knox Residence, 1983-84

1984 FAIA Unbuilt Design Award

1986 FSC/AIA Design Award

1988 Gulf Coast AIA Design Award

Florida Architect, September/October 1984: Vol. 31, No. 5, p. 48

Florida Home & Garden, August 1989: Vol. 5, No. 13, pp. 40-45

550 Biltmore Way, 1985 (with O. K. Houston and Glenn Pratt)

City of Miami Beautification and Environment Committee Award of Excellence, 1987

Windsor House, 1990-91 (with Rolando Llanes)

Florida Architect, May/June 1992: Vol. 39, No. 3

Architecture in Perspective VI, Catalogue and Traveling Exhibition, 1991

P. Crowe. *Architecture Rendering*, Quarto Publishing plc, 1991 pp. 45 & 213

Martinez House, 1991-92 (with Rolando Llanes)

1991 Miami AIA Unbuilt Design Award

1992 Florida AIA Unbuilt Design Award

Florida Architect, November/December 1992: Vol. 39, No. 6

Casa Egosita, 1992-93 (with Rolando Llanes)

1993 National ACSA Conference Juried Exhibition of Faculty Designed Artifacts

1993 Miami AIA Unbuilt Design Award

South Dade Animal Shelter, 1996 (with Rolando Llanes)

1996 FAIA Unbuilt Award of Excellence

1996 FSC/AIA Unbuilt Award of Excellence

Segalas House II, 1999 (with Rolando Llanes)

Residential Architect, July/August 2000: Vol. 4, No. 7, pp 63-65

Joint exhibitions

University of Virginia School of Architecture, Charlottesville, Virginia, 1984.

Architecture in Perspective IV. Traveling Exhibition, 1989.

Architecture in Perspective VI. Traveling Exhibition, 1991.

Center of Contemporary Arts, North Miami, Florida, 1991.

Miami Chapter AIA Gallery, Miami, Florida, 1991.

La Fondation Pour l'Architecture à Bruxelles, Belgium, 1991.

N. K. Gallery, Coral Gables, Florida, 1992.

Center of Fine Arts, Miami, Florida, 1993.

Bass Museum of Art, Miami Beach, Florida 1994.

Flat Land: Four Architects/Artists Project the City of Miami. Miami-Dade Public Library, Miami, Florida, 2017.

Solo exhibitions

T. A. Spain AIA: Drawings and Pastels, Coral Gables City Hall, Coral Gables, Florida, 2000.

T. A. Spain: A Retrospective, Coral Gables Museum, Coral Gables, Florida, 2013.

T. A. Spain: A Retrospective, Korach Gallery, University of Miami School of Architecture, 2014.

Publications

Drawings of Rome 1991-2001 Thomas A. Spain, Carie Penabad Editor, ISBN 0-9652301-5-5, Library of Congress Card Catalogue No. 2001097804.

Credits

Editors

Steven Fett

is a full-time lecturer at the University of Miami, School of Architecture. He is also assistant director of the School's Center for Urban and Community Design and a regular contributor to the School's Open City Studio program, an itinerant urban laboratory that travels during the summer months investigating how the architecture and urbanism of a city are influenced by culture. He received a Bachelor of Architecture from the University of Minnesota, and a Master of Architecture and Master of Urban Design at the University of Miami. Steven, a licensed architect, is the founder of his own architectural design and planning firm, Steven Fett Architecture, located in downtown Miami.

Edgar Sarli

has been a faculty member at the University of Miami School of Architecture since 2009. He received a Master of Architecture in Urban Design from Harvard University and a Bachelor of Architecture from the University of Miami. After collaborating in the office of Rafael Moneo for five years, he founded Loeb Sarli Architects. The firm's project-based research ranges from large scale urban interventions to a collection of portable furniture for contemporary nomadic urbanites. The office has won awards in Switzerland and Spain and has been exhibited at the 2010 Architecture Biennale in Venice.

Contributor

Jorge L. Hernandez

Architect, Coral Gables, Fla, is recognized internationally as a premier design firm whose work focuses on the context, climate and culture of each project. The firm has been recognized for its designs of civic and residential work, published throughout Europe, Latin America and North America. Historic preservation, preservation planning, and master planning of large scale projects and campuses are also part of the firm's expertise. Jorge received a Bachelor of Architecture from the University of Miami, and a Master of Architecture from the University of Virginia.

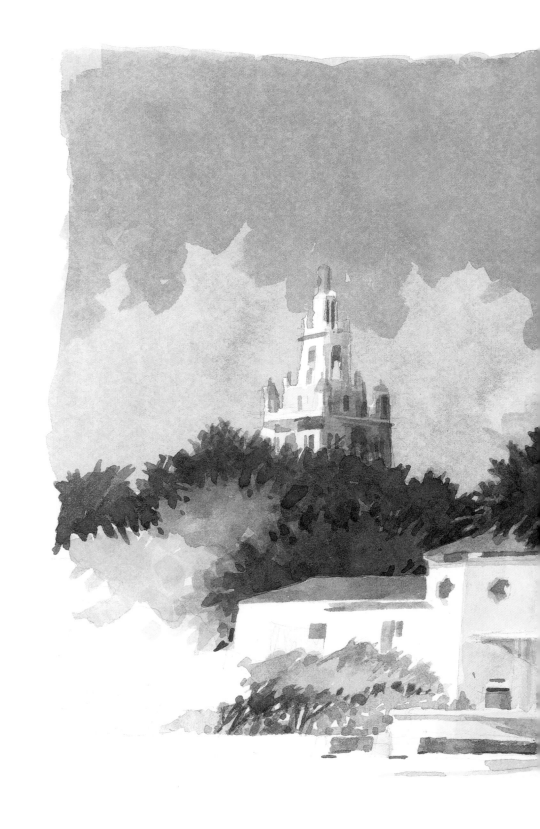

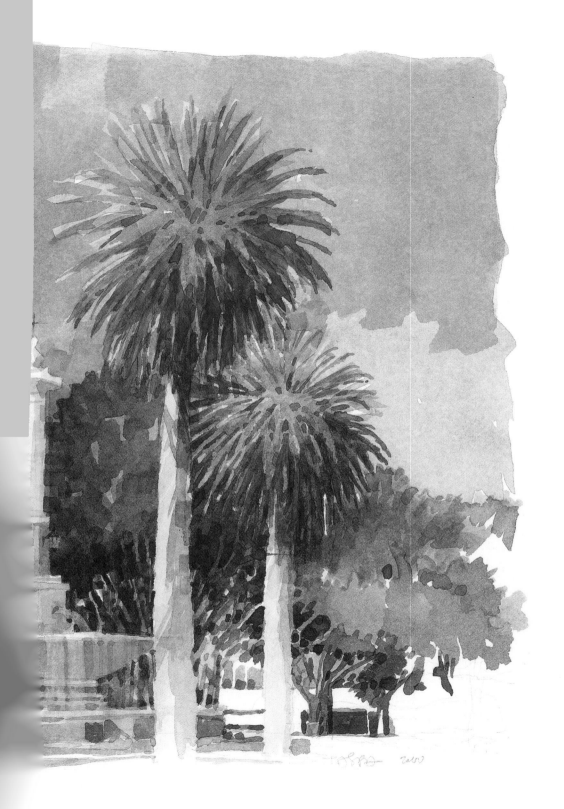

Book credits

Art Director: Oscar Riera Ojeda
Graphic Design: Lucía Bauzá

Additional Image Credits:
Page 2-3: Venitian Pool, 2012, Watercolor
Page 4: Pantheon, 1993, Color Pastel
Page 6-7: Dutch South African Village, 2009, Watercolor
Page 158-159: DeSoto Plaza, 2000, Watercolor

OSCAR RIERA OJEDA
PUBLISHERS

Copyright © 2018 by Oscar Riera Ojeda Publishers Limited
ISBN 978-1-946226-23-5
Published by Oscar Riera Ojeda Publishers Limited
Printed in China

Oscar Riera Ojeda Publishers Limited
Unit 4-6, 7/F.,
Far East Consortium Building,
121 Des Voeux Road Central, Hong Kong
T: +852-3920-9312

Production Offices | China
Suit 19, Shenyun Road,
Nanshan District, Shenzhen 518055
T:+86-135-5479-2350

www.oropublishers.com | www.oscarrieraojeda.com
oscar@oscarrieraojeda.com